CORPUS OF MAYA

HIEROGLYPHIC INSCRIPTIONS

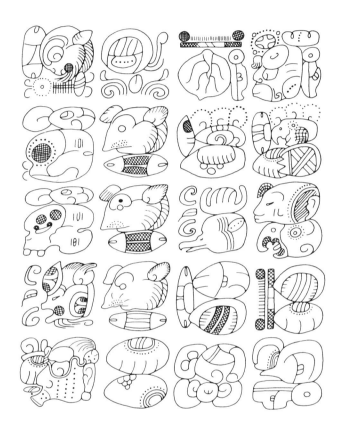

VOLUME 5 PART 1 XULTUN

CORPUS
OF
MAYA
HIEROGLYPHIC
INSCRIPTIONS

Volume 5 Part 1

ERIC VON EUW

*Research Fellow
in Maya Hieroglyphics
Peabody Museum, Harvard University*

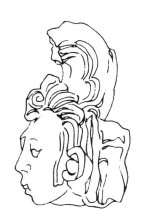

PEABODY MUSEUM
OF ARCHÆOLOGY AND ETHNOLOGY
HARVARD UNIVERSITY
CAMBRIDGE, MASSACHUSETTS

1978

ACKNOWLEDGMENTS

The publication of this fascicle was made possible through the generosity of:

 La Asociación Tikal

 Mrs. Katherine Benedict

 David D. Bolles

 Mrs. A. Murray Vaughan

Grateful acknowledgment is made to the Instituto de Antropología e Historia of Guatemala for their cooperation in authorizing the necessary work at Xultun. Fieldwork and preparation of the material published here were accomplished with support from the Stella and Charles Guttman Foundation of New York and the National Endowment for the Humanities.

Xultun

Xultun is located on high ground west of the Ixcan River (Río Azul), approximately 28 km east-northeast of Uaxactun. Several *aguadas* are within easy reach of the site. Three of these are fairly constant sources of water: El Delirio (2 km north), Los Tambos (2 km south), and Petipet (3.5 km west-southwest). Two other small *aguadas* (one 1.5 km south and the other 2 km southwest) are less reliable. Both of my journeys to the site began at Uaxactun, which is accessible year-round by plane and during the dry months by road from Tikal. I used the road in 1974 and traveled by plane in 1975. The route taken during my first visit to Xultun is indicated on the map.

Starting from Uaxactun in a northeasterly direction along the airstrip, one enters the Bajo de la Juventud and continues along the trail in the *monte bajo* for two hours (except for a few minutes in *serranía*) in a generally east-northeast direction. The path then turns eastward for approximately 2 km in changing terrain, before heading north for 4 km to the camp and *aguada* (dry in 1974) of La Palma (one crosses a dry riverbed a half hour before reaching La Palma).

From La Palma one continues east-southeast for a little less than 2 km (crossing mounds on two occasions) before heading generally northeast for 3 km, where, after crossing a *bajo*, more ruins can be noted. Traveling 2 km in an easterly direction, one traverses a group of structures (some of which have been looted), and, after an additional hour of east-northeast travel, comes to the camp and *aguada* of Santa María (actually a *corriente* or, here, a series of connected pools). Continuing slightly north of east for 8 km, one reaches the *aguada* of Hormiguero (dry in 1974). A *"trocopás"* (an old lumber road or "truck pass") from Yaloche to Dos Lagunas (now overgrown) is passed less than 2 km after leaving Santa María, and ruins and *chultunes* are seen often after crossing this old road.

From Hormiguero one follows a path south, passing several clusters of mounds before reaching the *aguada* of Petipet. Although the water at Petipet is the color of coffee, it is drinkable and fairly abundant. Fortunately this strangely named chicle camp retained its original name throughout the fifty years following the expeditions of the Carnegie Institution of Washington, as Xultun's approximate location was known in relation to that of Petipet. (Morley places Xultun about 3.5 km east of Petipet; it is actually slightly north of east.)

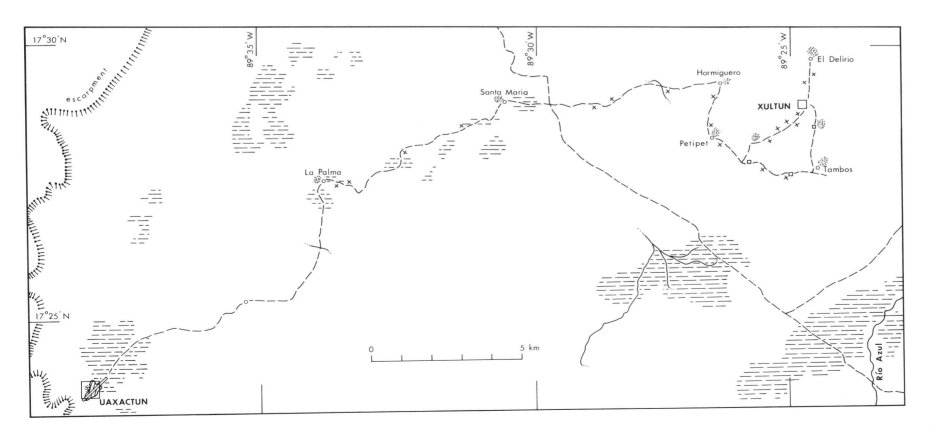

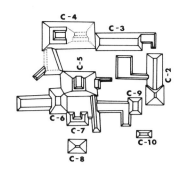

C-4
C-3
C-5
C-2
C-9
C-6
C-7
C-10
C-8

C-1

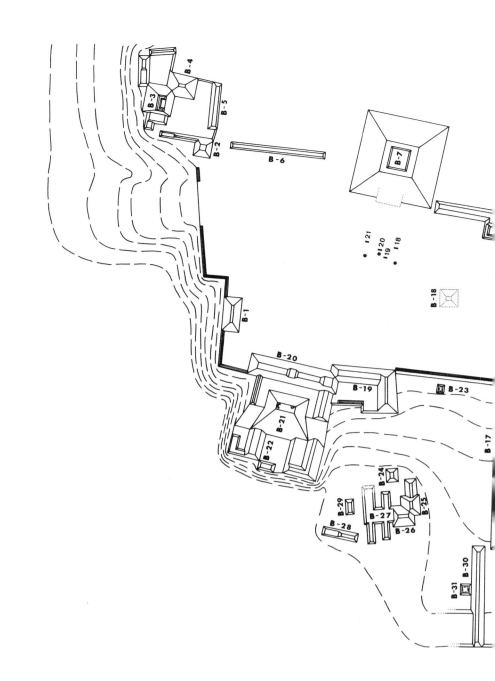

B-4
B-3
B-5
B-2
B-6
B-7

• I 21
•I 20
I 19
• I 18

B-18

B-1

B-20
B-19
B-23
B-21
B-22
B-17
B-24
B-25
B-29
B-27
B-28
B-26
B-30
B-31

THE RUINS OF XULTUN

100 m
0
20

magnetic

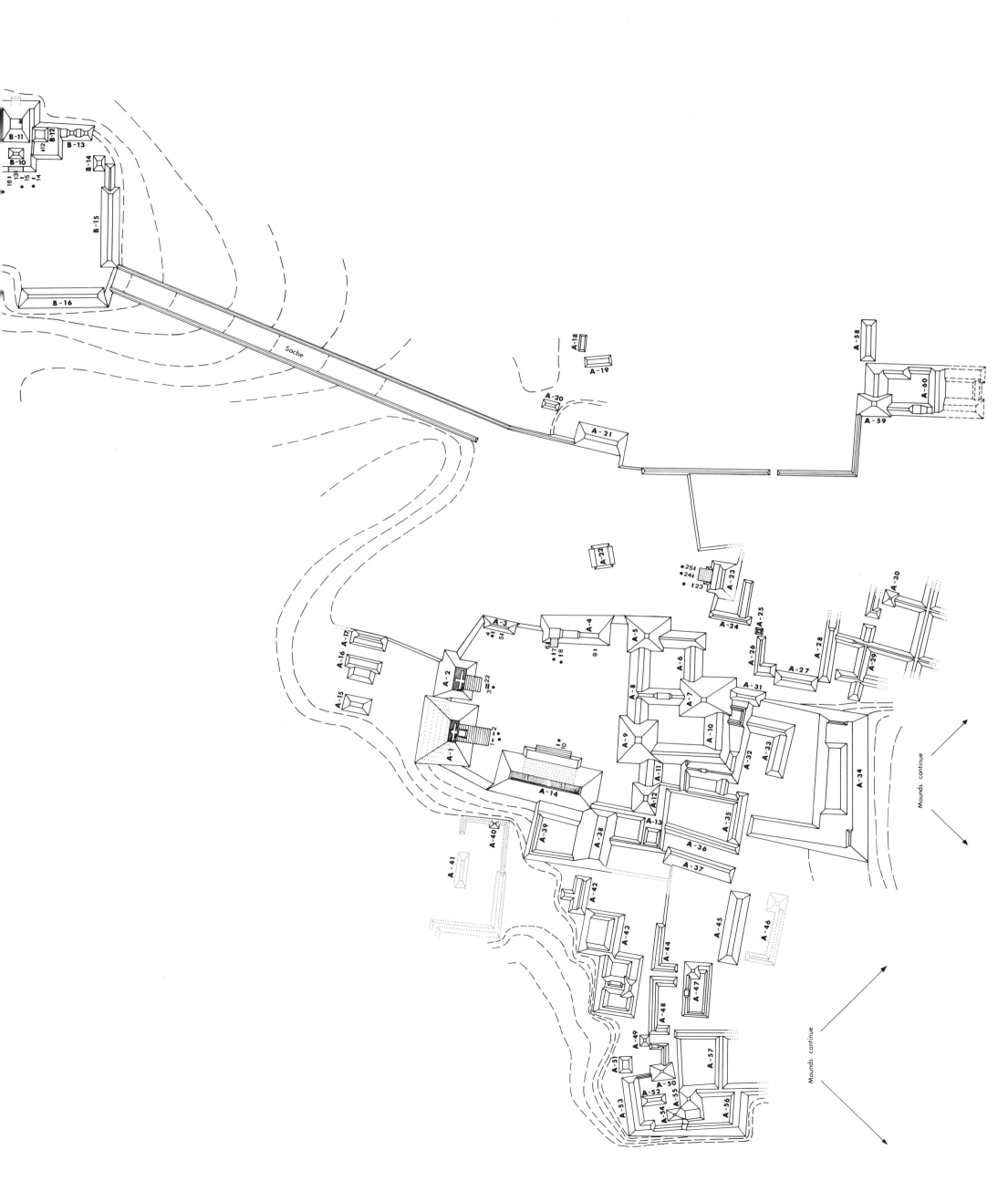

B-11
B-12
112
B-13
B-10
13
15
14
16
B-14
B-15
B-16
Sacbe
A-18
A-19
A-20
A-21
A-58
A-60
A-59
A-22
251
241
123
A-23
A-24
A-25
A-26
A-28
A-30
A-27
A-29
A-3
4
51
A-4
A-5
A-16 A-17
6
17
18
91
A-6
A-15
A-2
A-31
3 22
A-8
A-7
A-33
A-26
1 2
A-9
A-10
A-1
1
10
A-11
A-32
A-14
A-12
A-35
A-13
A-34
A-40
A-39
A-38
A-36
A-41
A-37
A-42
A-43
A-45
A-44
A-46
A-47
A-48
Mounds continue
A-49
A-57
A-51
A-50
A-53
A-52 A-55
A-54 A-56
Mounds continue

The path I took from Petipet to Xultun in 1974 was considerably longer than the actual distance separating the two sites (3.5 km). Following a roundabout set of trails, I traveled east-southeast for about one hour, then turned north near the abundant water source of Los Tambos, and continued in this direction for 3 km before reaching the center of Xultun. Another *aguada*, which was dry in 1974 but which supplied me with water the next season, is about halfway between Los Tambos and Xultun. Mounds are very much in evidence along this route, especially on the section closest to Xultun.

In 1975 I used a different route, shorter by 3 km (also indicated on the map), to leave the site. This path had been opened by a band of looters during the rainy season of 1974 in order to reach an *aguada* and camp southwest of the ruins. I also took a shorter, and unmapped, route in a westward direction from Petipet through the camps and *aguadas* of Arroyón and Caldero to reach Uaxactun.

The route taken by the expeditions from the Carnegie Institution of Washington in the 1920s (traveling northwest from Laguna Yaloche) is considerably longer than the paths I took.

PRINCIPAL INVESTIGATIONS AT THE SITE

In March 1920, about four and a half years after the site was discovered by a *chiclero* named Aurelio Aguayo, the Carnegie Institution of Washington (CIW) organized the first of three visits to Xultun with its Fourth Central American Expedition. At that time S.G. Morley and C.E. Guthe gave the site its name, which may be translated as "end stone" or "closing stone" — a reference to the late date recorded in Stela 10 (10.3.0.0.0 1 Ahau 3 Yaxkin). During the three-day exploration, Stelae 1 to 17 were found (although the numeration was changed slightly later on) and a partial plan of Group A was made (Morley 1920, pp. 322-324). Less than a year later Morley, together with O.G. Ricketson, Jr. and A.K. Rutherford, spent a week at Xultun with the Fifth Central American Expedition. At this time Stelae 18 to 22 were found and additional notes and photographs were secured (Morley 1921, pp. 359-362). The last visit was made in April 1923, when the Seventh Central American Expedition stopped in Xultun, and W.A. Love and Ricketson determined the coordinates for the site. All the information known about this site up until the time of my explorations was the result of these three visits and was subsequently published in *The Inscriptions of Peten* (Morley 1937-38, vol. 1, pp. 383-422).

My work at the site was carried out during two visits: the first from March 23 to April 15, 1974, and the second from February 15 to March 18, 1975.

NOTES ON THE RUINS

Considering the short time Morley and his colleagues spent at Xultun, it is remarkable how much information they were able to retrieve from the site. Although their visits totaled only ten days, they managed to find all but three of the stelae, photograph the majority of them, and produce a reasonable plan of most of Group B and the central area of Group A, plus a good description of the site (Morley 1937-38, pp. 385, 386). Morley was obviously well aware that the site had been inadequately surveyed and that it extended over a considerably larger area than he was able to include in his map.

In 1975 I spent approximately ten days mapping the site. It soon became apparent that I, too, would be unable to cover the entire area, but would have to concentrate on the central groups alone, as the site continued in many directions, especially to the south and west. Although for the most part the structures become smaller and less densely spaced as they spread out, they extend for at least 1 to 1.5 km to the south, 2 km to the southwest, and clusters are found all the way to El Delirio, 2 km north, and may continue beyond. The ruins do not seem to extend east of Group B, however.

In general, Morley's designations for the structures have not been followed, because the several new features that were incorporated into my plan made changes in numeration desirable.

Some new discoveries were made during my explorations: three stelae (23, 24, 25) and a ball court (Structures A-16, A-17) were found. The large Structure C-1, north of Group B, had apparently been missed by the CIW, as had the *sacbe* connecting the southwest corner of Group B to a large flat area (on which Stelae 23 to 25 and the building they face are located, as is the ball court some 200 m north of the stelae). Many additional mounds were added to Group A, and the western part of Group B was found to be more complex and extensive than Morley had indicated.

The largest structure at Xultun is Structure B-7. Its base is almost square, each side measuring about 45 m; it rises 24 m to a platform supporting a small structure 1.5 m high. Four stelae (18 to 21) were set in front and approximately 30 m west of this massive structure. At its northern end, B-7 is connected by a long, low construction to a small group of mounds, and to the south it is connected by another low building to a platform supporting several structures (B-9 to B-12); five stelae (13 to 17) were set up in front of this platform, and Stela 12 was placed on top of it, west of Structure B-12. To the north and to the west (and to some extent to the south) of the large plaza of Group B, there is a rather sharp drop in the terrain; construction seems to have been confined generally to the flat raised area. Most of the structures demarcating this high terrain are relatively low, except for the northwest group (Structure B-21 rises from the ground level 8.5 m in the east and 12 m in the west). Two long structures (B-17 and B-30) and a cluster of smallish mounds (B-24 to B-29) complete this group.

About 150 m north of the northernmost structures of Group B is Structure C-1, one of the largest at Xultun: the base is approximately 30 by 35 m, and it reaches a maximum height of 16.5 m (intermediate terraces are at 8, 9, and 10 m). Some 80 m north of C-1 is a group of medium-sized mounds. I limited my explorations of Group C to C-1 and this cluster of mounds.

A number of impressive constructions enclose the main plaza of Group A, which is raised approximately 5 m above the surrounding terrain. The highest and most imposing of these structures is A-1, where the pyramidal substructure rises very steeply to a height of 24.5 m and is surmounted by a vaulted building 5.5 m high. The rear of A-1 reaches a height of 35 m above the ground, even though the roofcomb has collapsed. Stelae 1 and 2 were set in front of the stairway leading up to the temple of A-1; and Stelae 3 and 22 (which is directly behind Stela 3) were set facing the stairway of Structure A-2, just east of A-1. Structure A-2 rises 16 m above the plaza floor. Stela 10 was set in front of another impressive mound (A-14) on the west side of the plaza. This building is 60 m long at the base, and where the roofcomb survives, reaches a height of 17 m. Six stelae were placed on the eastern side of the plaza (Stelae 4 and 5 facing A-3; Stelae 6 to 9 facing A-4).

The southern side of the main plaza of Group A is also very impressive with three imposing structures (A-5, A-7, and A-9) which rise steeply to heights of 19, 17, and 15.5 m respectively and are connected by buildings 4.5 to 7 m high, forming two small courts.

South and west of the main plaza many other structures were built, forming a large number of courts, often with fair-sized mounds in one corner.

The last three stelae (23 to 25) were set facing south (in front of Structure A-23), the only ones so placed at the site.

The ball court (A-16 and A-17) was built north of Structures A-1 and A-2. The area between the ball court and Group B and west of the *sacbe* is a large *guanal*.

Standing on Structure A-54, at the edge of an 8 m drop in the terrain, looking westward, I wrote in my notebook, "many mounds visible, some

large." Similar observations were made looking south from Structures A-56, A-46, A-34, and A-30. There was not sufficient time to extend the map further. Other fairly high mounds are A-54 (10.5 m), B-11 (9 m), and A-12 and A-38 (8 m), and there are many structures higher than 5 m. Three sunken structures (A-25, B-23, B-31) were noted as well.

REMARKS No evidence was found to support Morley's placement of some of the altars. As a matter of fact, no altars were found for Stelae 5, 9, and 19; the one for Stela 20 was questionable at best, as it consisted of nothing more than rubble. There was an altar approximately equidistant from Stelae 16 and 17, rather than in front of Stela 16, as Morley indicated. Nor was Morley's Altar A-1 found, although there is a limestone outcropping at the approximate location indicated by the CIW map.

Latex molds were made of the glyph panels on the fronts of Stelae 4, 5, 9, 14, 15, 16, 18, 19, 20, 21, 23, 24, and 25 and of the front of Stela 22 and of the lowest ("slave") panel of Stela 4.

In the early seventies, Stelae 3 and 12 were looted; in late 1974 Stela 10 disappeared. At the time of my first visit to the site, large trenches had been dug into Structures A-5, A-7, A-9 and many smaller buildings. (The looters were active in the site when we arrived, but left four days later when it became apparent that we planned an extended stay). A year later Structures A-1, A-2, A-3, A-5 (again) and many others had been tunneled through by people who made a camp by a small *aguada* southwest of the site. Xultun has been savagely looted: more than 50 trenches have been made, representing the illicit activity of a number of men for many weeks in the removal of many tons of stone.

REGISTER OF INSCRIPTIONS AT XULTUN Stelae 1 to 10 and 12 to 25
The top fragment of Stela 13 was incorrectly called Stela 11 by Morley. To avoid confusion, Morley's designations of the other monuments have not been altered, and the recently discovered stelae have been assigned new numbers. As a result, there no longer exists a Stela 11 at Xultun.

REFERENCES CITED MORLEY, SYLVANUS G.
 1920 "Archaeology," *Carnegie Institution of Washington Yearbook 19.* Washington, D.C.
 1921 "Archaeology," *Carnegie Institution of Washington Yearbook 20.* Washington, D.C.
 1937-38 *The Inscriptions of Peten.* Carnegie Institution of Washington, Publication 437, 5 vols. Washington, D.C.

Xultun, Stela 1

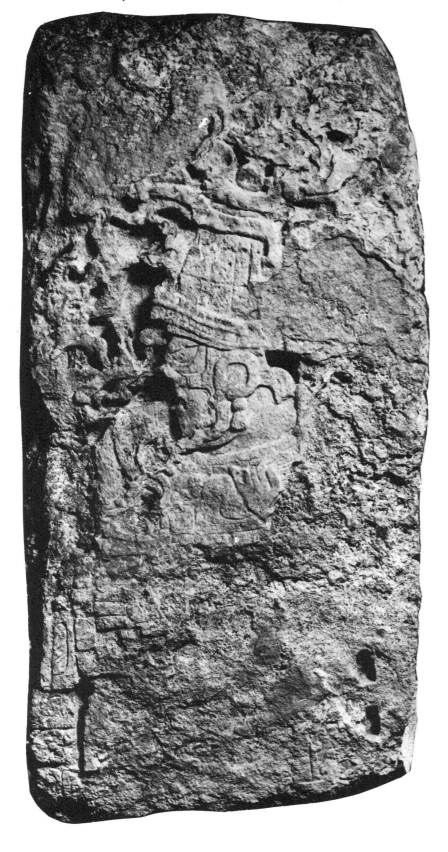

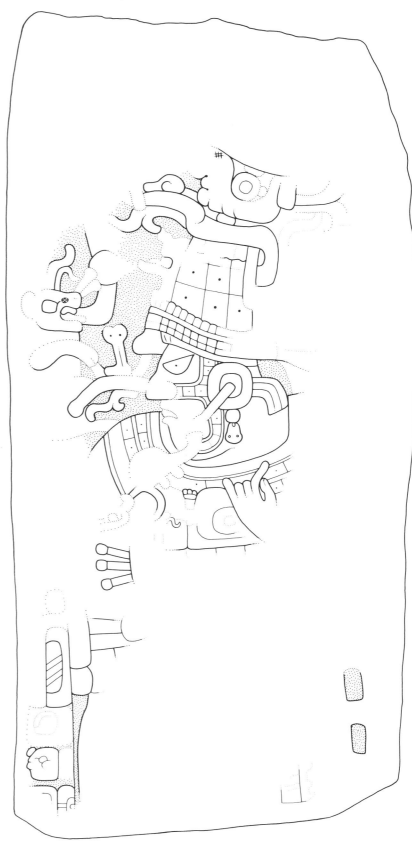

pA

1

2

3

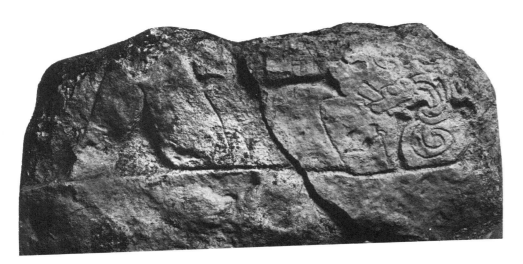

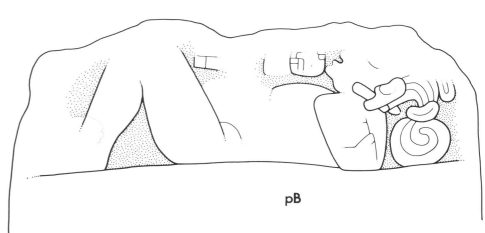

pB

LOCATION In 1920, the CIW found the main fragment leaning slightly forward on the west side of the stairway leading to Structure A-1. In 1974 the base was found in situ, buried in debris behind the larger fragment.

CONDITION Most of the carved surface had flaked off, leaving only small areas of the main fragment and of the bottom piece with sculptural detail. The sides and back have also suffered from flaking and weathering, but as they most likely had been left uncarved, the damage is rather unimportant. An intermediate fragment probably no longer exists.

MATERIAL Poor quality limestone.

SHAPE Parallel sides. Shape of top unknown.

DIMENSIONS Main fragment:

H	2.20 m
MW	1.06 m
MTh	0.57 m
Rel	8.0 cm

Bottom fragment:

HLC	0.40 m
PB	0.50 m plus
WBC	1.24 m
MW	1.24 m
MTh	0.60 m
Rel	2.0 cm

CARVED AREAS Front only.

PHOTOGRAPHS von Euw.

DRAWINGS von Euw; based on field drawings corrected by artificial light.

REMARKS Because of the difference in width between the two fragments, they may actually be parts of two stelae. However, in antiquity the larger fragment may simply have broken, and then was shaved down and reset. (The rather flat lower edge may not, in fact, be a natural break.) If this were the case, then the sides may have been carved at one time.

Xultun, Stela 2

LOCATION The stela was found in situ and erect in 1920 by the CIW on the east side of the stairway leading up to Structure A-1.

CONDITION Considerable weathering has obliterated much of the detail.

MATERIAL Limestone with many inclusions.

SHAPE Tapering gradually to a rounded top. The cross section is in the approximate shape of a semi-ellipse, with the carved surface representing the large axis.

DIMENSIONS

HLC	1.84 m	
PB	unknown	
MW	1.11 m	
WBC	1.11 m	
MTh	0.45 m	
Rel	0.3 cm	

CARVED AREAS Front only.

PHOTOGRAPH von Euw.

DRAWING von Euw; based on field drawing corrected by artificial light.

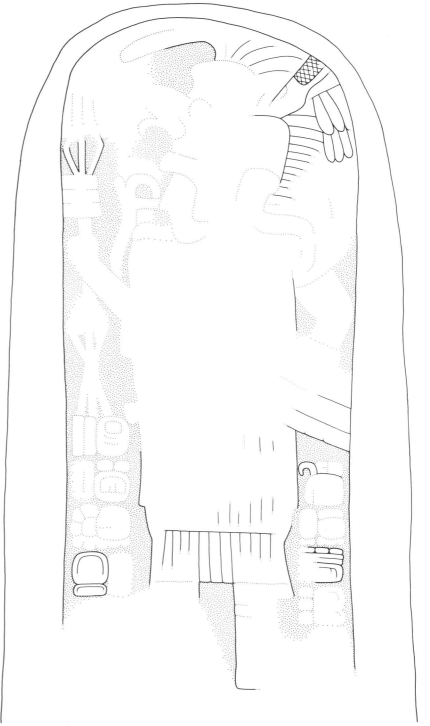

Xultun, Stela 3

LOCATION The stela was found by the CIW with the front half lying face down and the back half standing in situ in front of the stairway leading to Structure A-2. Stela 3 was set directly in front of the similarly oriented Stela 22. By 1974 the carved face of the stela had been looted (it had probably been taken out about three years before).

CONDITION When Morley first examined this monument, the front half was broken into two fairly well preserved pieces. The sides, however, had eroded considerably, and large portions had flaked off.

MATERIAL Poor quality limestone.

SHAPE Generally rectangular.

DIMENSIONS
HLC 2.42 m
PB unknown
MW 1.03 m
MTh 0.74 m
Rel 2.5 cm (sides)

CARVED AREAS Front and sides.

PHOTOGRAPHS Front and right side: CIW. Left side: von Euw.

DRAWINGS von Euw; the left side and the lower portion of the right side are based on field drawings corrected by artificial light. The remaining drawings are based only on CIW photographs.

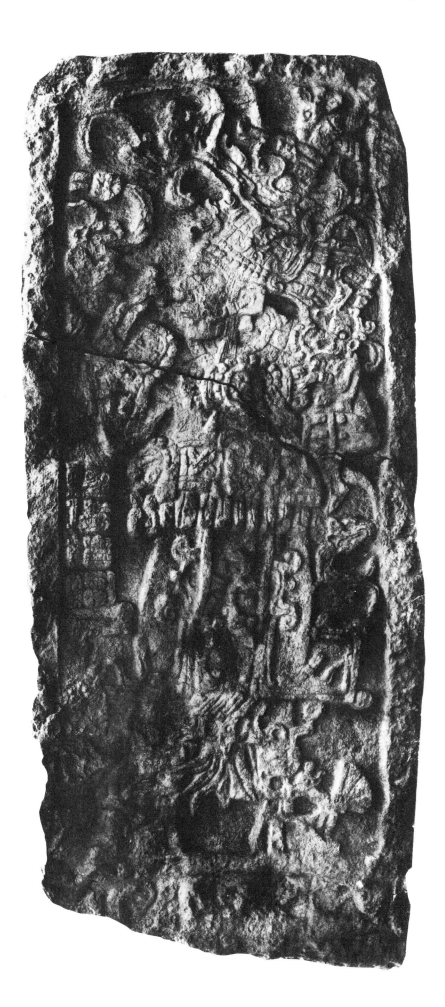

A

1

2

3

4

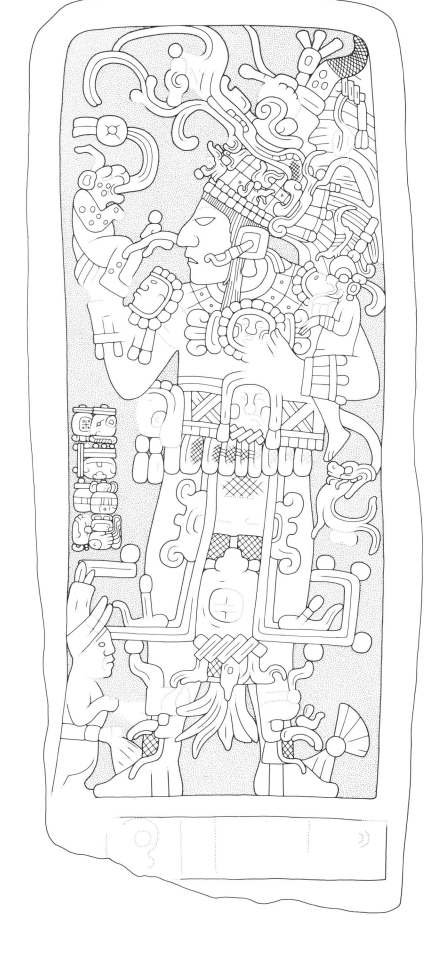

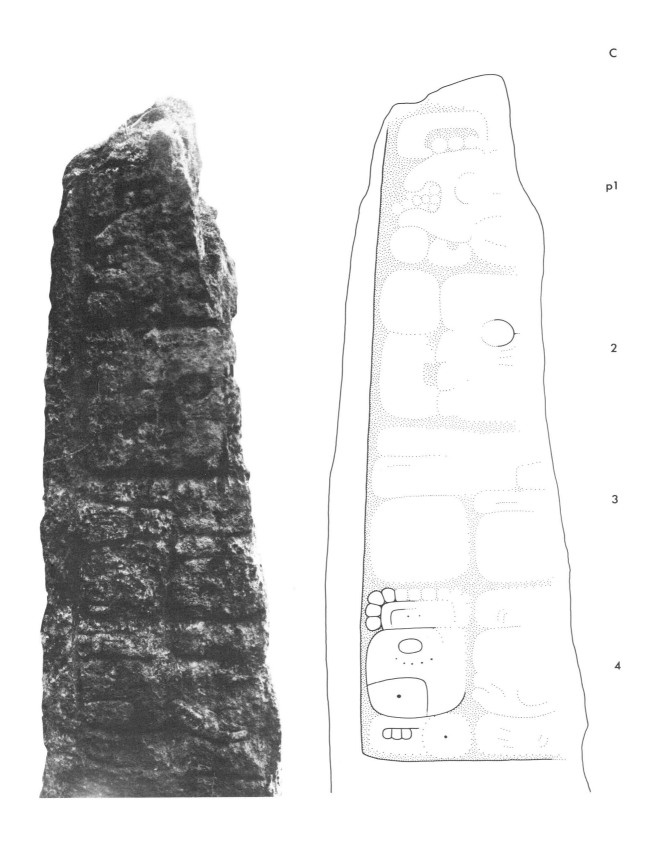

C

p1

2

3

4

Left side

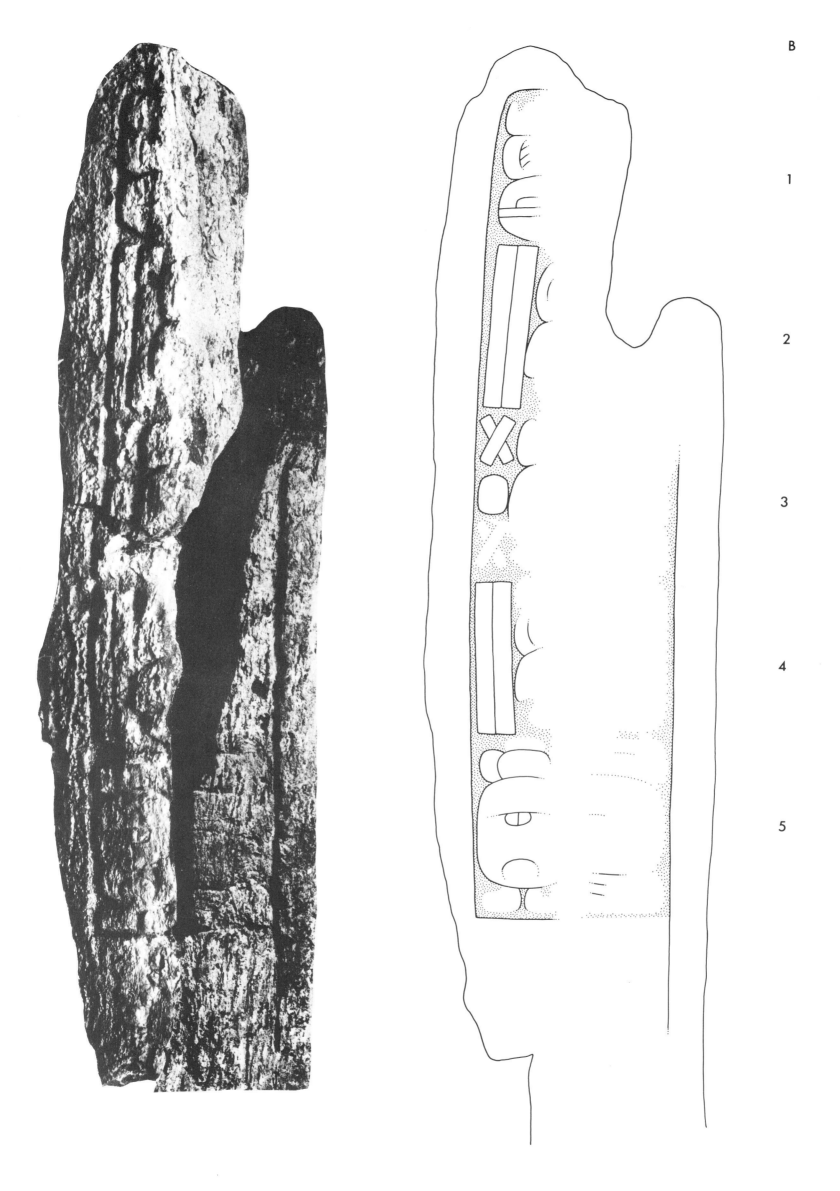

B

1

2

3

4

5

Right side

Xultun, Stela 4

LOCATION Northernmost of the two standing stelae facing Structure A-3; discovered in 1920 by the CIW.

CONDITION The front of the stela (which is in one piece) has weathered irregularly: the top section has lost almost all detail to flaking and erosion, while the bottom remains in relatively good condition. The sides are poorly preserved.

MATERIAL Poor quality limestone.

SHAPE Parallel sides, with a slightly rounded top.

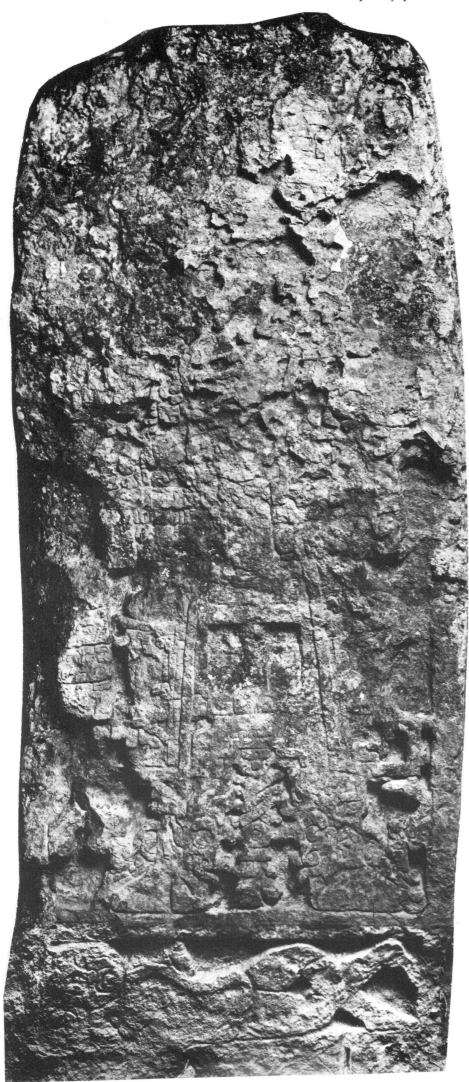

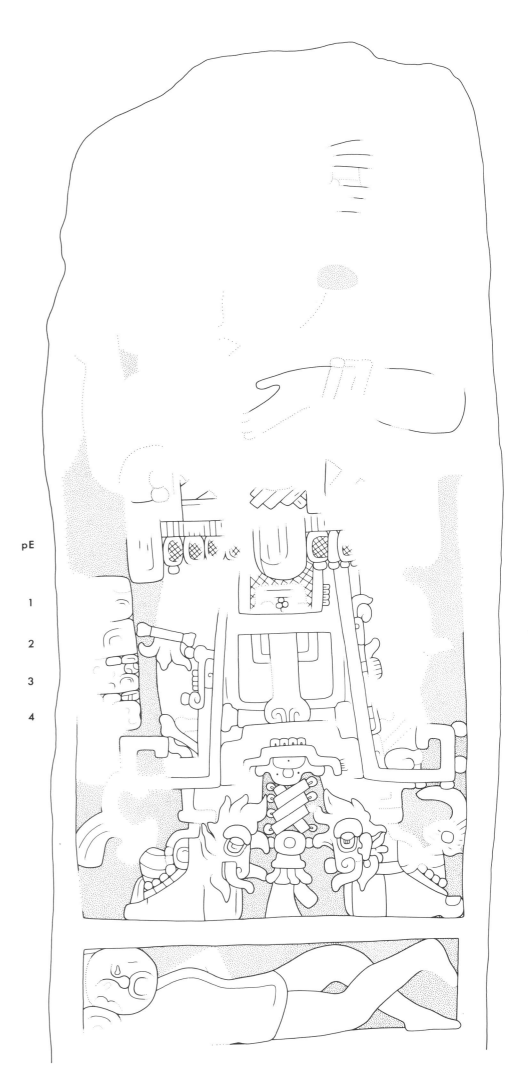

pE

1

2

3

4

DIMENSIONS
HLC 2.70 m
PB 0.20 m plus
MW 1.19 m
WBC 1.17 m
MTh 0.83 m
Rel 3.2 cm

CARVED AREAS Front and sides.

PHOTOGRAPHS von Euw; bottom panel printed from a CIW negative and rectified using the photograph of a plaster cast of the panel.

DRAWINGS von Euw; based on field drawings corrected by artificial light.

REMARKS In late 1974, Structure A-3 was looted, and most of Stela 4 was buried under stones extracted from the structure during tunneling. A latex mold of the bottom panel was taken in 1974, because the position of the stela's altar made it impossible to photograph the stela.

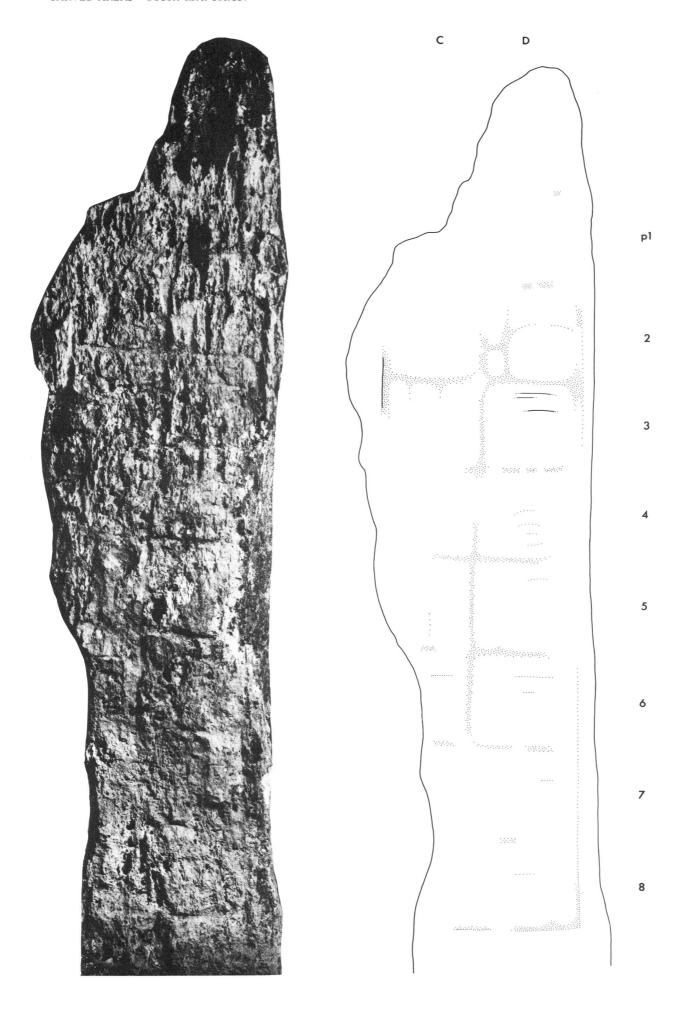

Left side

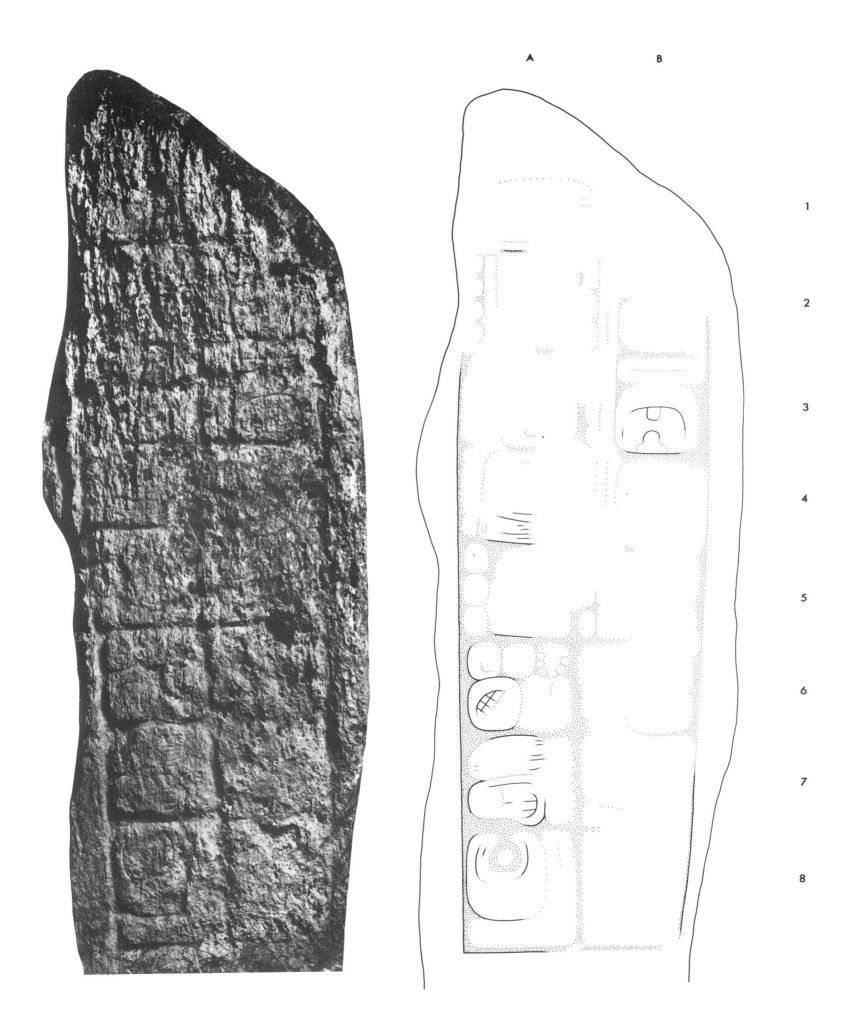

Right side

Xultun, Stela 5

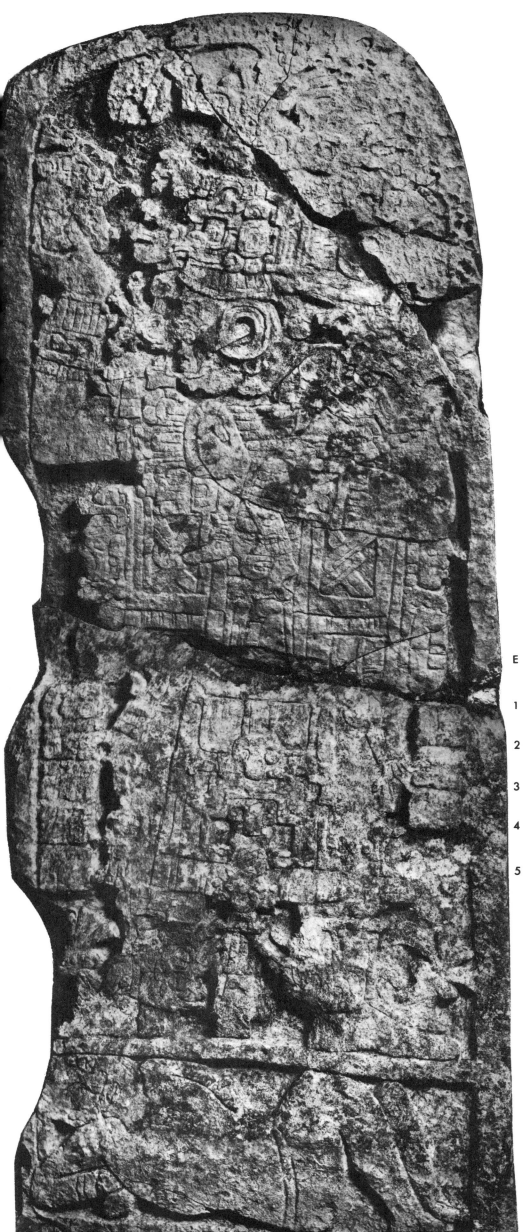

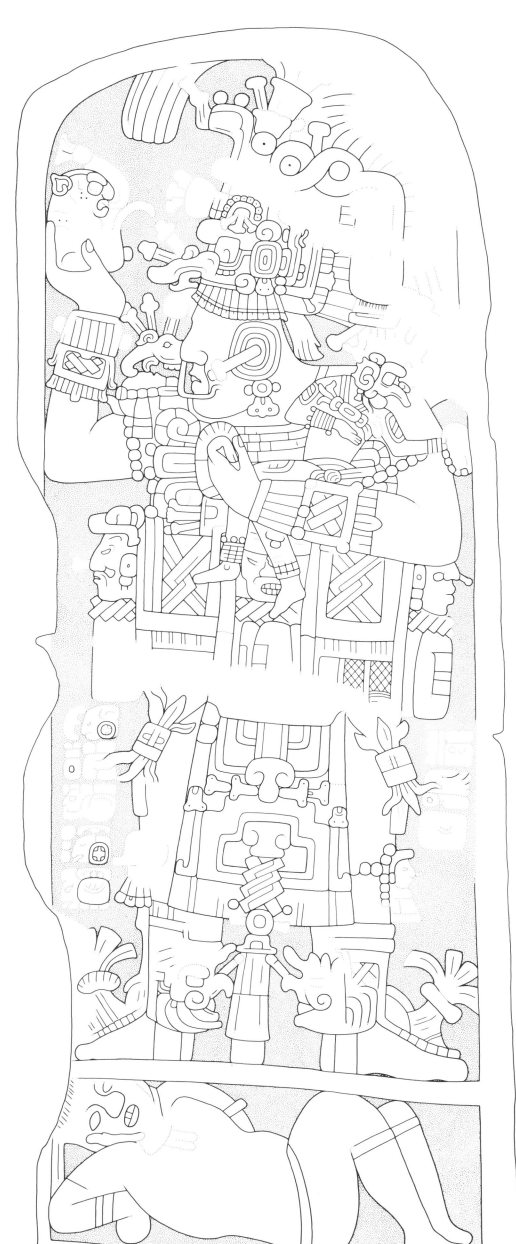

E

1

2

3

4

5

F

1

2

3

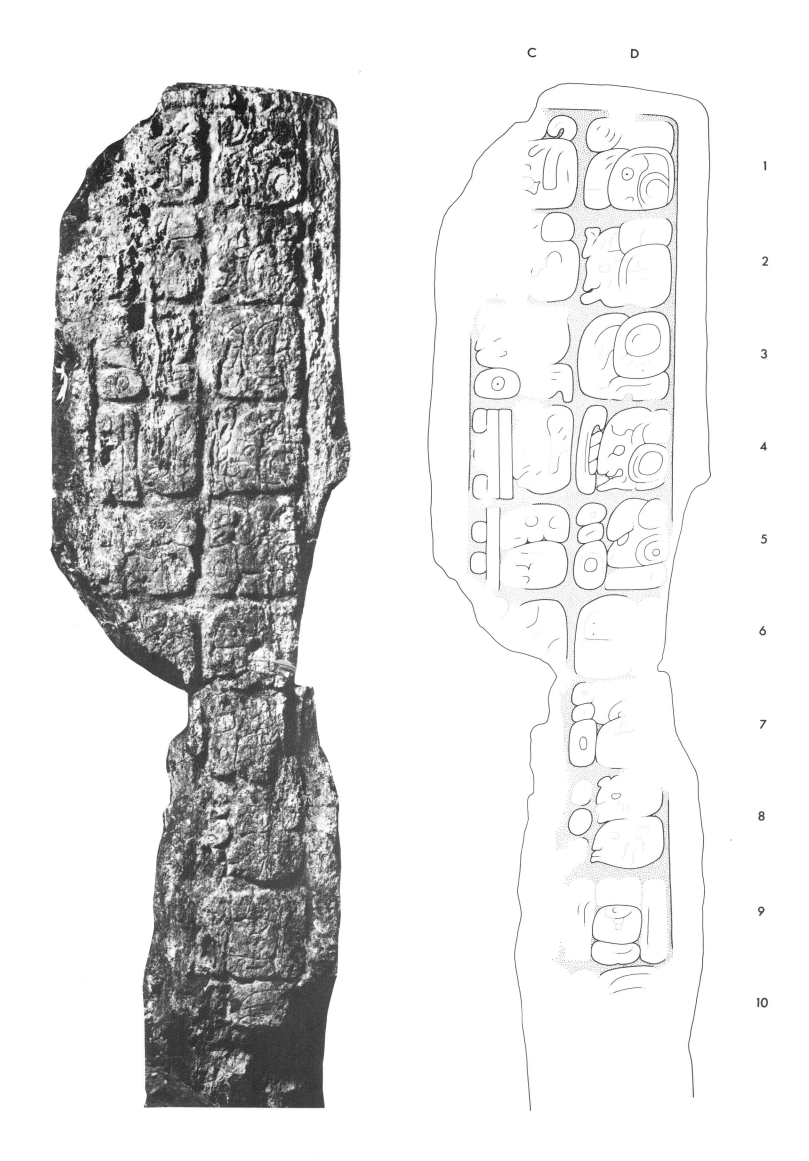

Left side

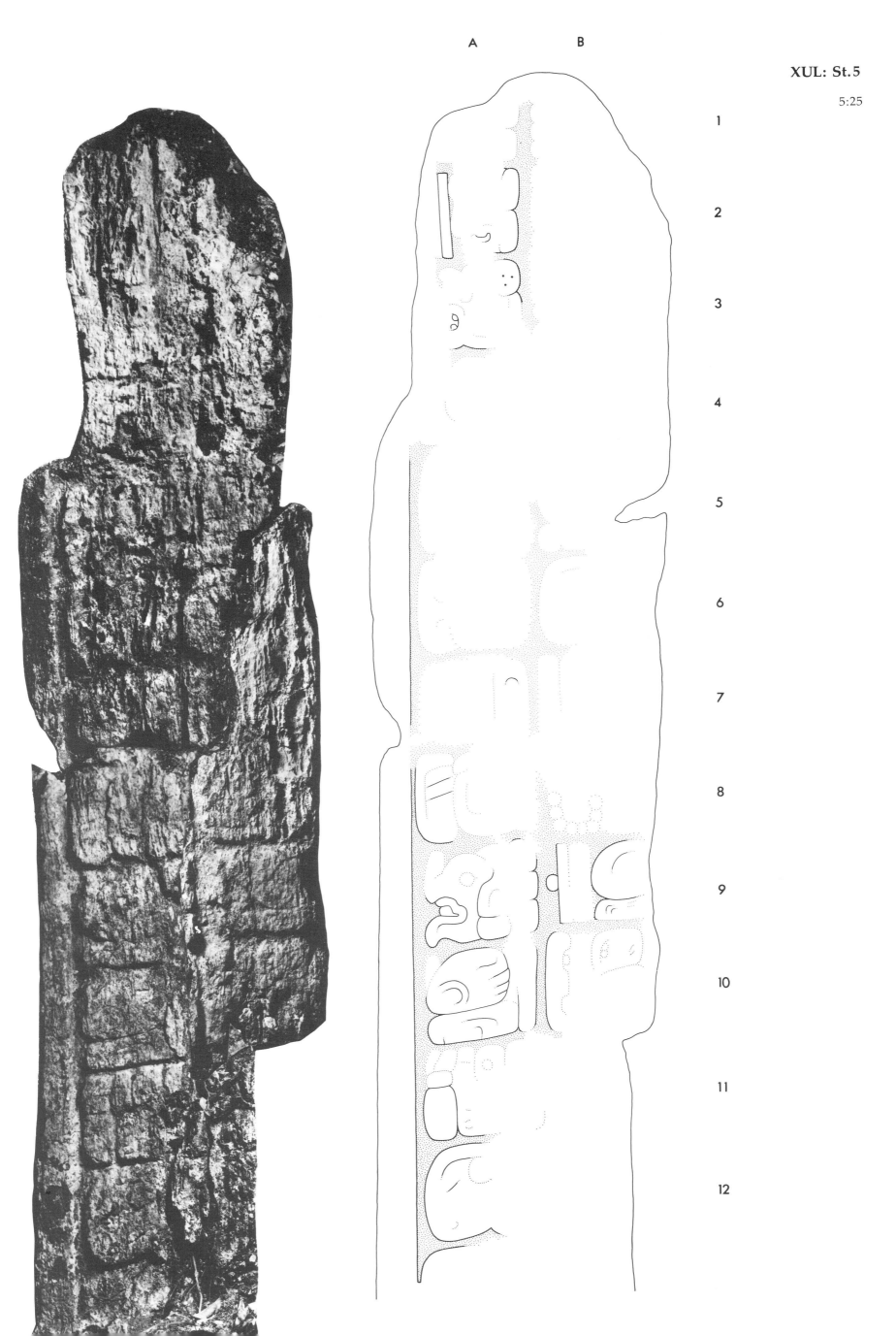

A B

XUL: St.5

5:25

1

2

3

4

5

6

7

8

9

10

11

12

Right side

LOCATION Next to (and south of) Stela 4, facing Structure A-3.

CONDITION When first discovered by the CIW in 1920, Stela 5 was broken into two pieces, the top fragment having fallen in front of the standing lower half. By 1974 a large fragment of the bottom portion had split off. The upper right-hand corner, consisting of three pieces, was found in 1974 buried under the top half of the stela. The front is reasonably well preserved, but the sides have lost considerable detail to erosion and flaking.

MATERIAL Poor quality limestone.

SHAPE Parallel sides, with a slightly rounded top.

DIMENSIONS

HLC	3.34 m	
PB	unknown	
MW	1.28 m	
WBC	1.28 m	
MTh	approximately 0.80 m	
Rel	5.0 cm	

CARVED AREAS Front and sides.

PHOTOGRAPHS von Euw.

DRAWINGS von Euw; based on field drawings corrected by artificial light.

REMARKS The recently found fragment almost certainly had split off before the stela broke in two, as it was found lying close to the base of the stela, rather than in its proper position relative to the larger fragment. Morley reads the coefficient at B9 as "almost surely eight," but no evidence was found for more than one dot. No altar was found associated with this monument.

Xultun, Stela 6

LOCATION This stela was discovered standing at the northwestern corner of Structure A-4 in 1920 by C. E. Guthe of the CIW.

CONDITION The stela is in one piece, although considerable flaking has destroyed much of the sculptured surface. The front has almost no detail left, and much of the sides (especially the left side) has been badly eroded. The stela was left lying on its side.

MATERIAL Poor quality limestone.

SHAPE Parallel sides, with flattish top.

DIMENSIONS
HLC	1.52 m	
PB	0.37 m	
MW	0.92 m	
WBC	0.88 m	
MTh	approximately 0.59 m	
Rel	8.0 cm	

CARVED AREAS Front and sides.

PHOTOGRAPHS von Euw.

DRAWINGS von Euw; based on field drawings corrected by artificial light.

C D

p1

2

3

4

5

6

Left side

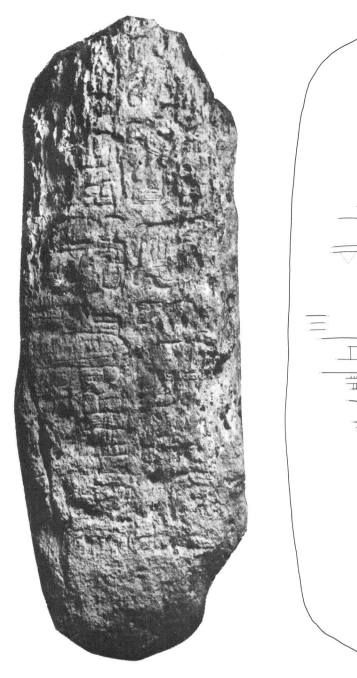

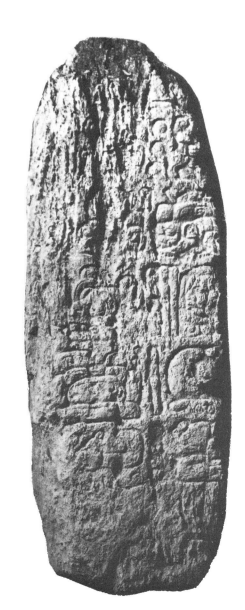

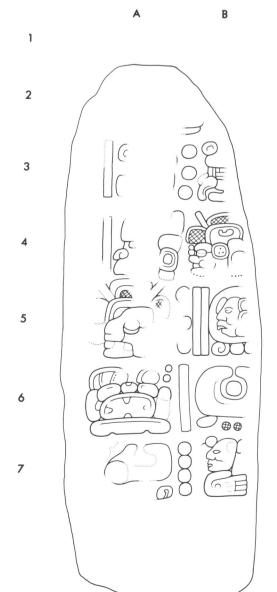

A B

1

2

3

4

5

6

7

Right side

Xultun, Stela 7

LOCATION In the main plaza of Group A, facing Structure A-4. Stela 7 is slightly north of Stela 8.

CONDITION It has broken into three large fragments. It was found lying on its face by the CIW in 1920, and the condition was so ruinous then that Morley did not recognize the Initial Series on the left side of the monument. Obviously, the stela's condition has deteriorated even further since Morley's time.

MATERIAL Poor quality limestone.

SHAPE Parallel sides, with slightly rounded top.

DIMENSIONS
HLC	2.01 m	
PB	1.27 m	
MW	1.10 m	
WBC	1.06 m	
MTh	approximately 0.63 m	
Rel	2.4 cm	

CARVED AREAS Front and sides.

PHOTOGRAPHS von Euw.

DRAWINGS von Euw; based on field drawings corrected by artificial light.

REMARKS The lettering of the glyph columns has been changed from that used by Morley: the pairs A and B and C and D have been reversed.

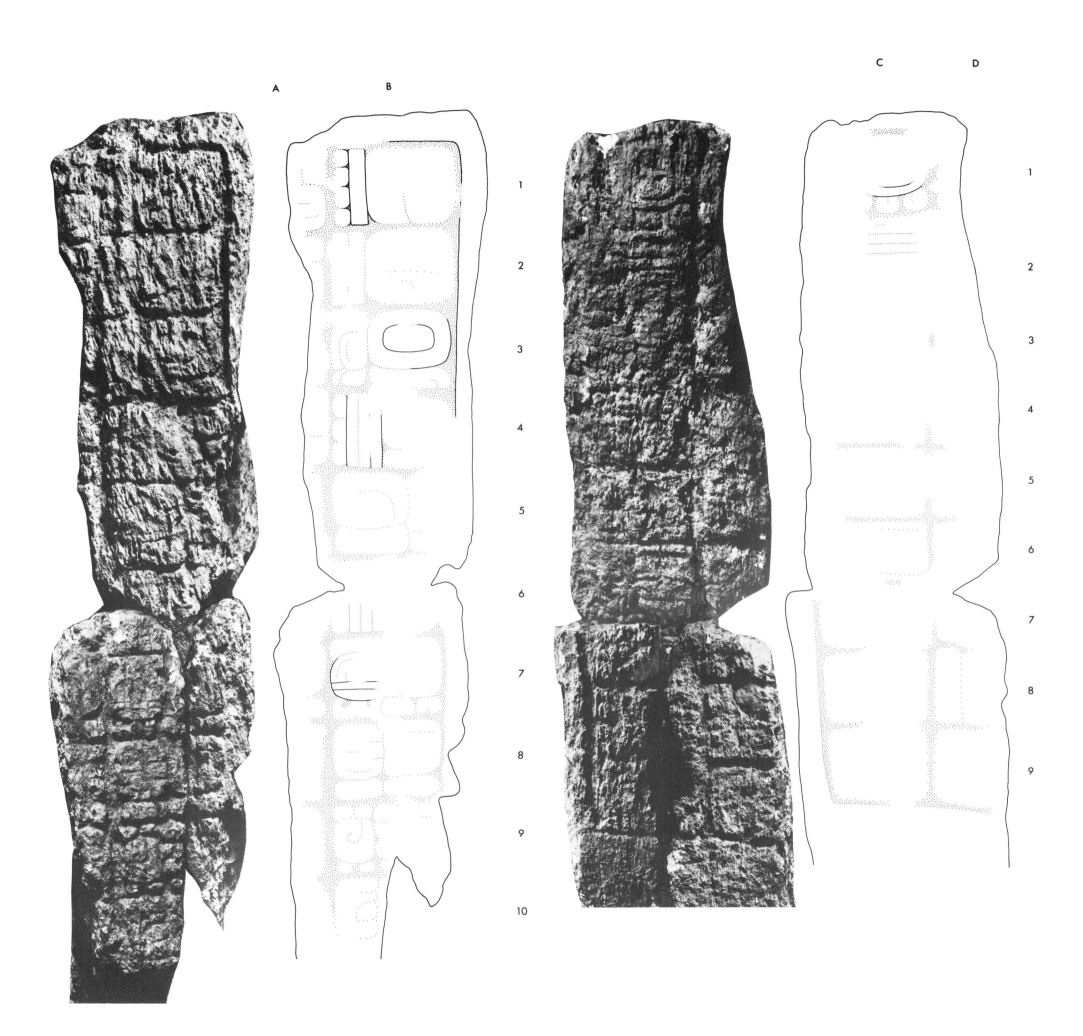

Right side

Xultun, Stela 8

LOCATION The stela was found in 1920 by the CIW facing Structure A-4 and lying between Stelae 7 and 9.

CONDITION Unbroken, it was found lying on its face under a large tree. Only the lower portion of the stela retains any detail, the rest being severely eroded. The sculptured sides have also lost almost all detail owing to flaking and weathering. The stela was left lying on its face.

MATERIAL Soft limestone.

SHAPE Parallel sides, with a slightly rounded top.

DIMENSIONS

HLC	2.40 m	
PB	0.16 m	
MW	0.98 m	
WBC	0.94 m	
MTh	approximately 0.74 m	
Rel	3.5 cm	

CARVED AREAS Front and sides.

PHOTOGRAPHS von Euw.

DRAWINGS von Euw; based on field drawings corrected by artificial light.

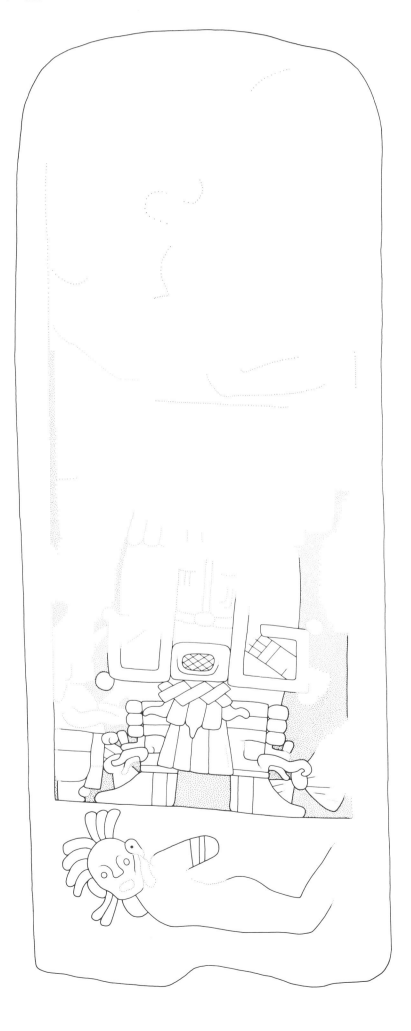

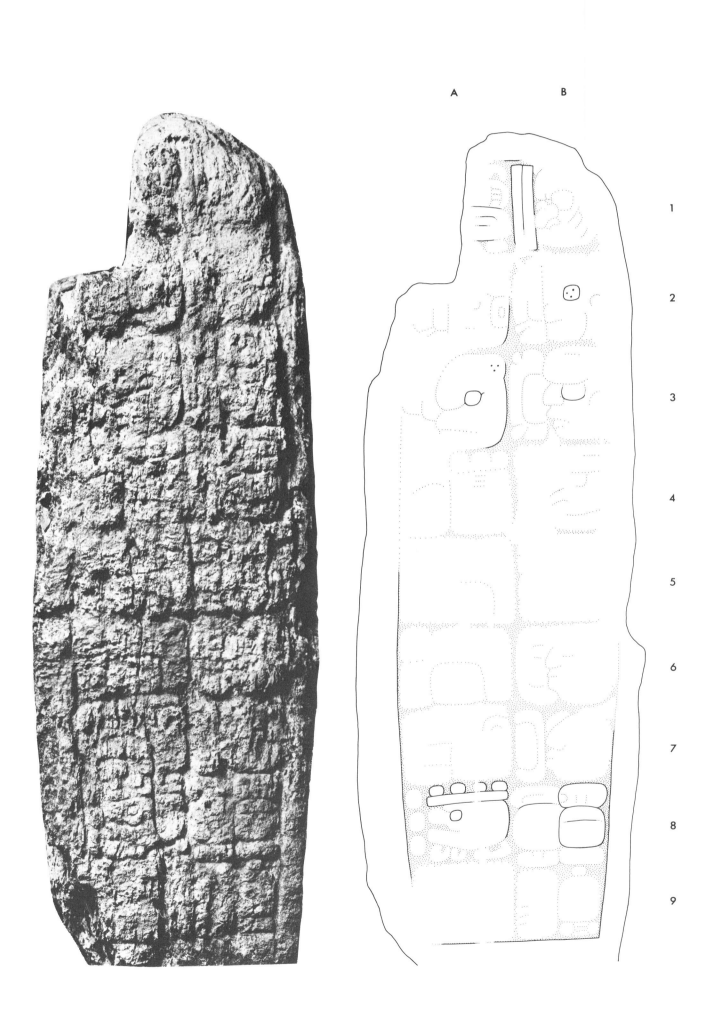

Left side

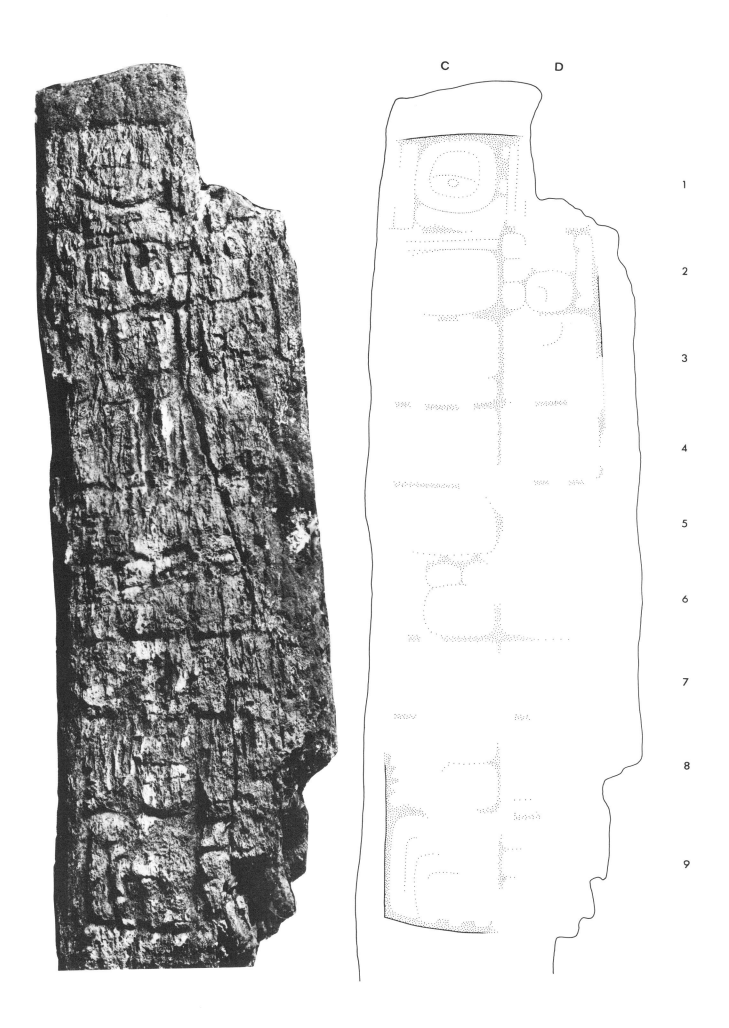

Right side

Xultun, Stela 9

LOCATION Southernmost of the stelae facing Structure A-4.

CONDITION In 1920, when the stela was first discovered by the CIW, it was lying face down with a large *ramón* tree growing on top of it. Assuming that the stela had been completely crushed by the weight of the tree, Morley never turned it over. In 1974 the tree, still growing on the stela, was cut down with considerable effort, and the stela was turned over. The roots of the *ramón* had encircled the stela, and its weight had cracked and crushed the stone. However, the sculptured surface on the front of the stela (though in several pieces) is well preserved except in some small areas. The lower fragment, including the legs of the personage and the base, has been almost completely destroyed and now amounts to little more than rubble.

Even though a large percentage of the sculptured surface has survived, the condition of the stone can hardly be described as being anything but very poor, since the stone is, for the most part, quite friable and many powderlike chips break off except when handled with extreme care. A few small fragments were glued onto some of the larger pieces. About two-thirds of the inscriptions on the sides have flaked off. The stela was left lying face up and was covered with dirt.

MATERIAL Poor quality limestone.

SHAPE Parallel sides, with rounded top.

DIMENSIONS (of illustrated fragments)
HLC 2.16 m
MW 1.27 m
MTh approximately 0.55 m
Rel 7.0 cm

CARVED AREAS Front and sides.

PHOTOGRAPHS von Euw.

DRAWINGS von Euw; based on field drawings corrected by artificial light.

REMARKS Morley mentions a rectangular altar associated with this stela, but no altar of any type was found.

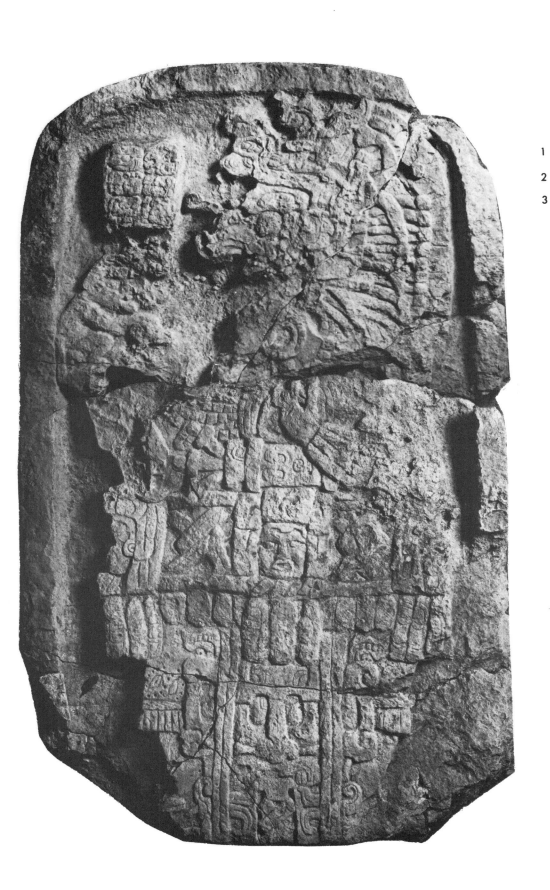

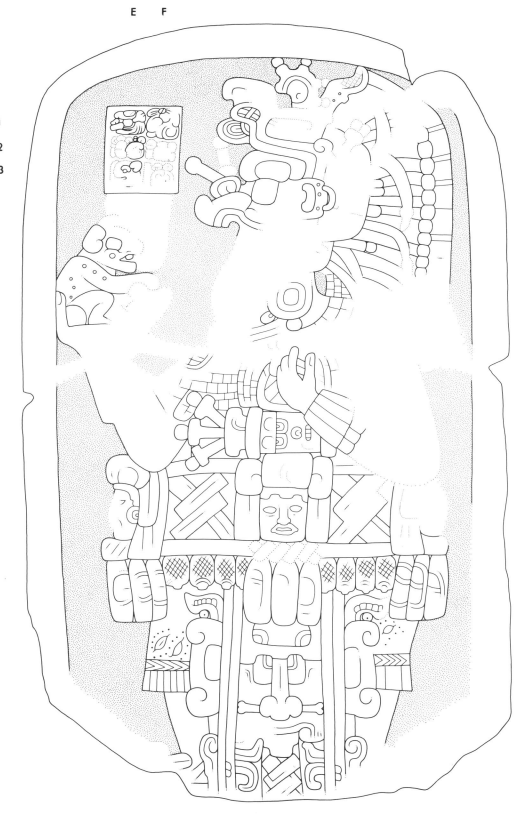

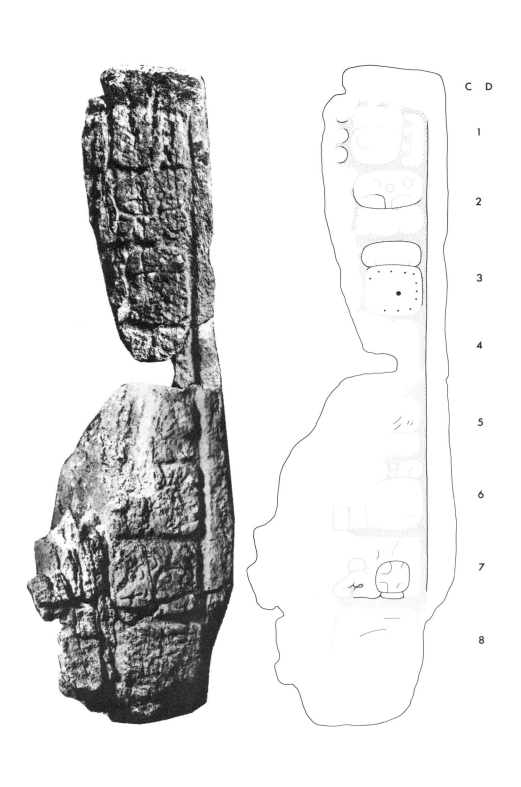

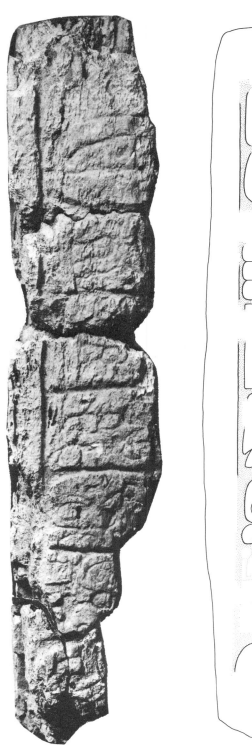

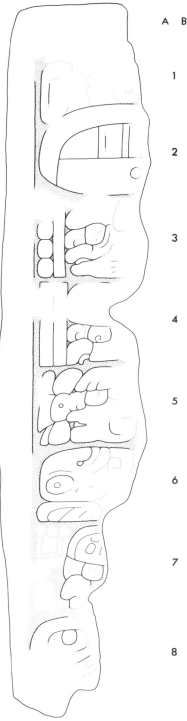

C D

1
2
3
4
5
6
7
8

A B

1
2
3
4
5
6
7
8

Left side

Right side

Xultun, Stela 10

LOCATION In 1974 Stela 10 was found lying face down (as it was left by CIW in 1920) in front of the stairway of Structure A-14. When Xultun was revisited in February 1975, the stela had been looted, and its present whereabouts is unknown.

CONDITION Although the stela has lost about half of its thickness to erosion and flaking and has broken into three large pieces, the front of the stela is in an excellent state of preservation. One small fragment was glued to the middle piece. The carved surface of the stela is quite irregular.

MATERIAL Porous limestone.

SHAPE Generally rectangular.

DIMENSIONS

HLC	1.88 m	
PB	0.55 m	
WBC	0.79 m	
MW	0.79 m	
MTh	approximately 0.38 m	
Rel	2.0 cm	

CARVED AREAS Front and sides.

PHOTOGRAPHS von Euw.

DRAWINGS von Euw; based on field drawings corrected by artificial light.

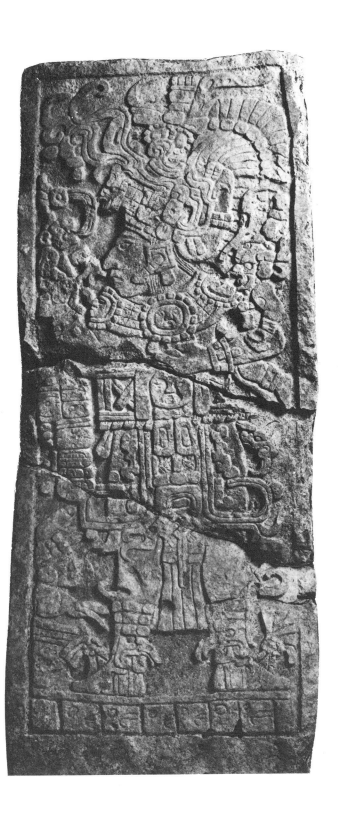

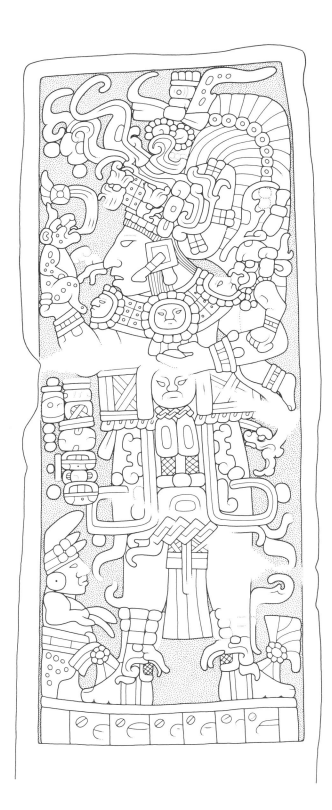

A

1

2

3

4

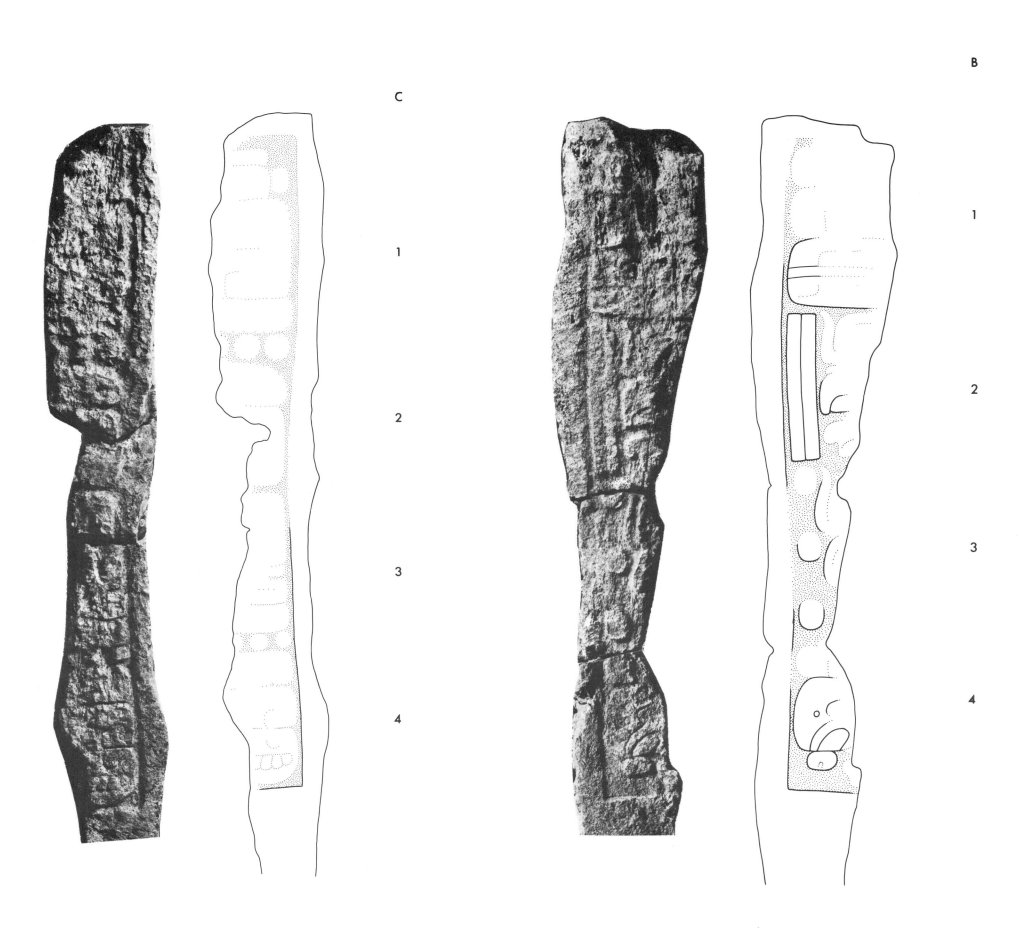

C

B

1

1

2

2

3

3

4

4

Left side

Right side

Xultun, Stela 12

LOCATION The stela was found by the CIW in 1920 still in place on the west side of Structure B-12. By 1974 it had disappeared from the site. It had been sawn to reduce its thickness during the looting some three years before. Its present whereabouts is unknown.

CONDITION Because of the rather poor quality of the CIW photograph (the monument apparently had been wet for that purpose), it is difficult to judge the condition of the stela without personal inspection. It undoubtedly had weathered considerably, as details were particularly difficult to make out from the photograph.

MATERIAL Limestone.

SHAPE Tapering gradually to a fairly square top.

DIMENSIONS H 2.46 m
MW 1.04 m
WBC 1.04 m
MTh 0.56 m
Rel unknown

CARVED AREAS Front only.

PHOTOGRAPH CIW.

DRAWING von Euw; based on the CIW photograph only.

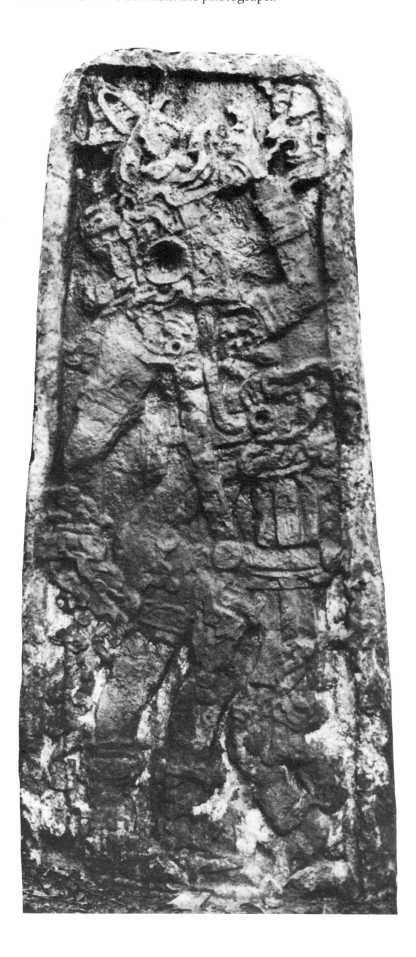
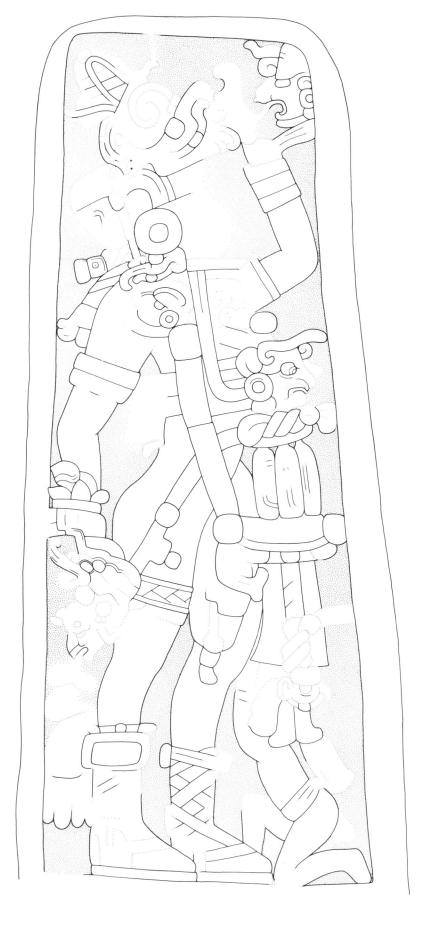

Xultun, Stela 13

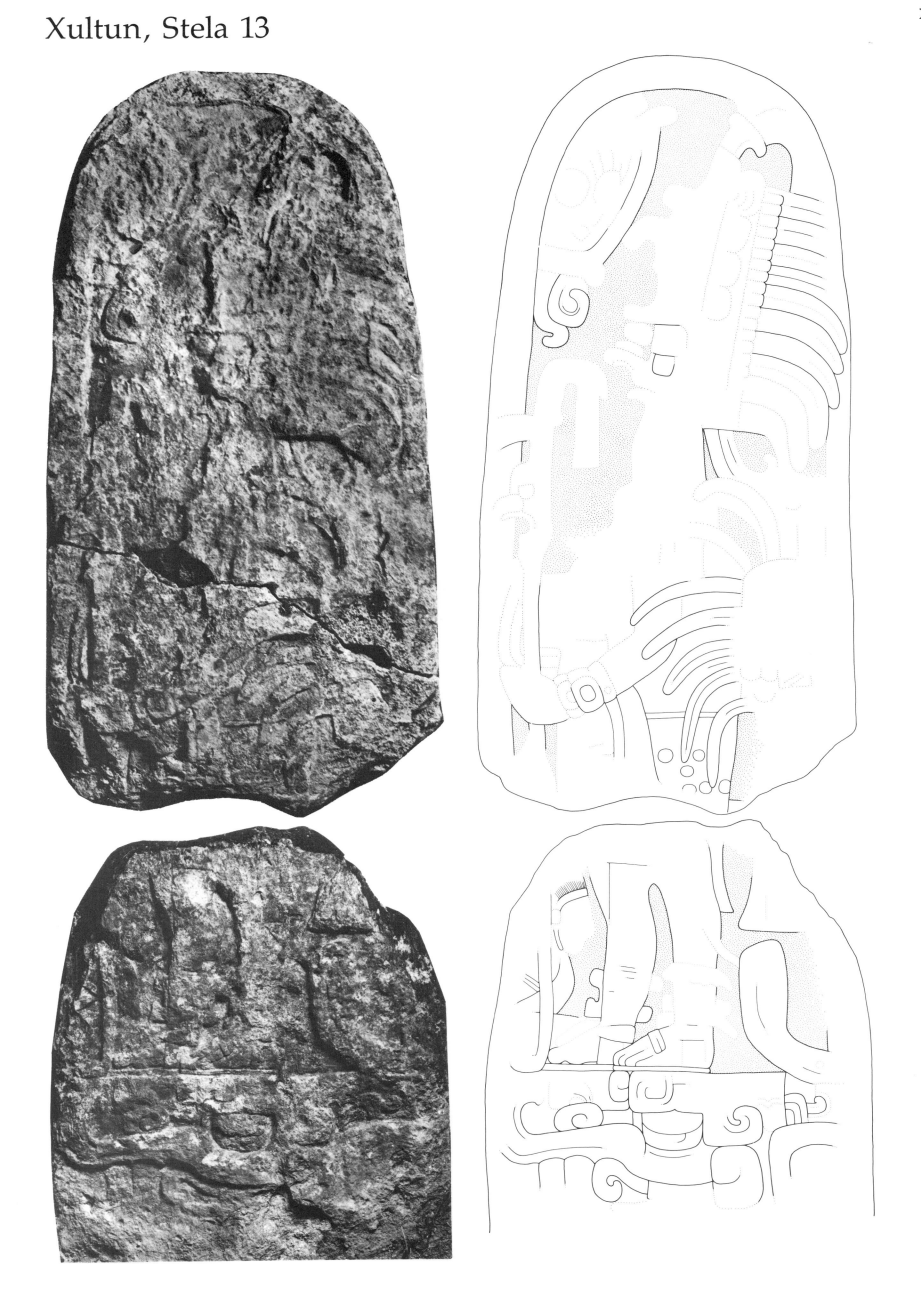

LOCATION The lower fragment of the stela is standing in place at the base of the stairway leading up to Structure B-10. The upper portion of the stela was found lying against a tree in the passage east of Structure B-14.

CONDITION In 1920 the stela was found in two pieces: Morley called the lower piece Stela 13 and classified the upper fragment as Stela 11. It seems probable that both pieces are in fact parts of the same stela, now known as Stela 13. Both fragments have suffered greatly from erosion, and considerable flaking has destroyed most of the inscriptions on the sides. The upper fragment has broken in two since Morley's visit and has also lost additional detail owing to weathering and flaking.

MATERIAL Poor quality limestone.

SHAPE Generally parallel sides gradually tapering to a rounded top.

DIMENSIONS

HLC	approximately	3.16 m
PB	unknown	
MW	1.05 m	
WBC	1.05 m	
MTh	approximately	0.50 m
Rel	2.5 cm	

CARVED AREAS Front is carved in relief; the sides are carved in a combination of intaglio bars and dots and intaglio rilevato glyphs (they may almost be considered heavily incised).

PHOTOGRAPHS von Euw.

DRAWINGS von Euw; based on field drawings corrected by artificial light. Some details were obtained from CIW photographs.

REMARKS Morley erroneously states that the bottom fragment had no inscriptions on its sides; inexplicably he also states that the break in the upper fragment occurred immediately below Glyph A-4, whereas, in fact, three more glyphs are clearly visible.

Left side

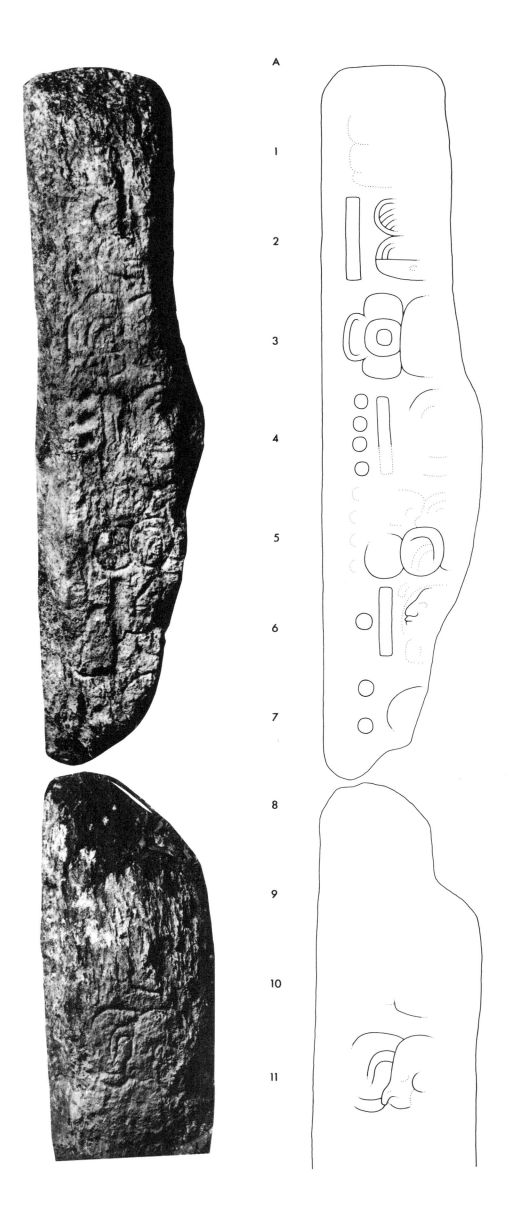

A

1

2

3

4

5

6

7

8

9

10

11

Right side

Xultun, Stela 14

LOCATION Southernmost of the five stelae facing Structure B-10.

CONDITION It was found lying face down in 1920 by the CIW. Morley tried to turn it over, but "it was found to be so rotten that the stone scaled off and crumbled, and the attempt had to be abandoned." In 1974, Stela 14 was turned over, a process that took approximately four days. The central portion had crumbled and disappeared. At the top of the stela often more than 95 percent of the thickness had disintegrated; bits and pieces were carefully reassembled (a rather tedious enterprise due to the great variability of the thickness in the fragments that remained). Much of the stela has completely disappeared so that numerous gaps remain, and the pieces that have somehow survived have lost much detail to erosion. The carved surface of this stela (similar to many other monuments in Xultun) is quite irregular.

MATERIAL Very porous limestone.

SHAPE Parallel sides, with slightly rounded top.

DIMENSIONS HLC 3.34 m (estimated)
PB 0.55 m plus
MW 1.32 m
WBC 1.32 m
MTh approximately
 0.70 m
Rel 2.3 cm

CARVED AREAS Front and sides.

PHOTOGRAPHS von Euw.

DRAWINGS von Euw; based on field drawings corrected by artificial light.

REMARKS Additional fragments were photographed, but since their relative position remains undetermined, they are not included here. The sides of the monument were photographed before it was turned over. Other stelae found lying face down were handled in a similar manner.

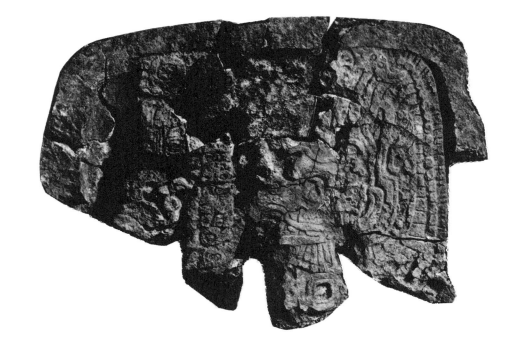

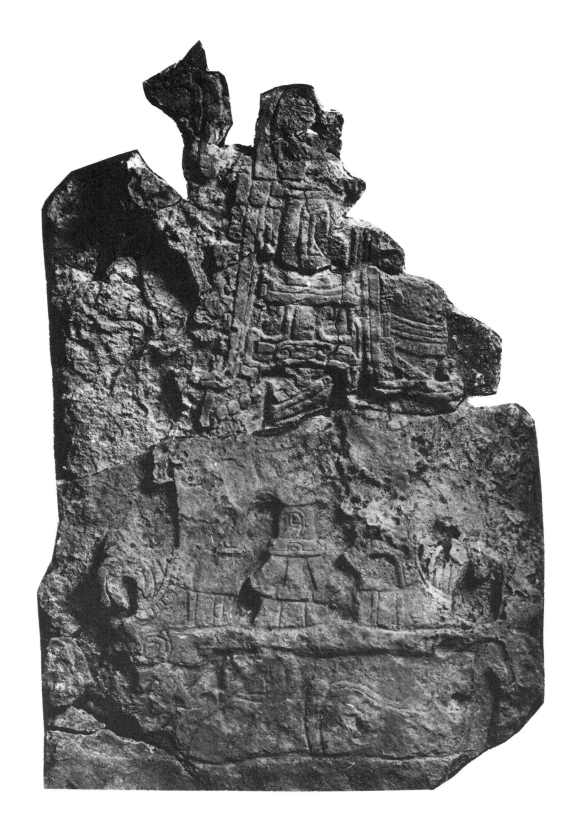

5:46

C D

1
2
3
4
5
6
7

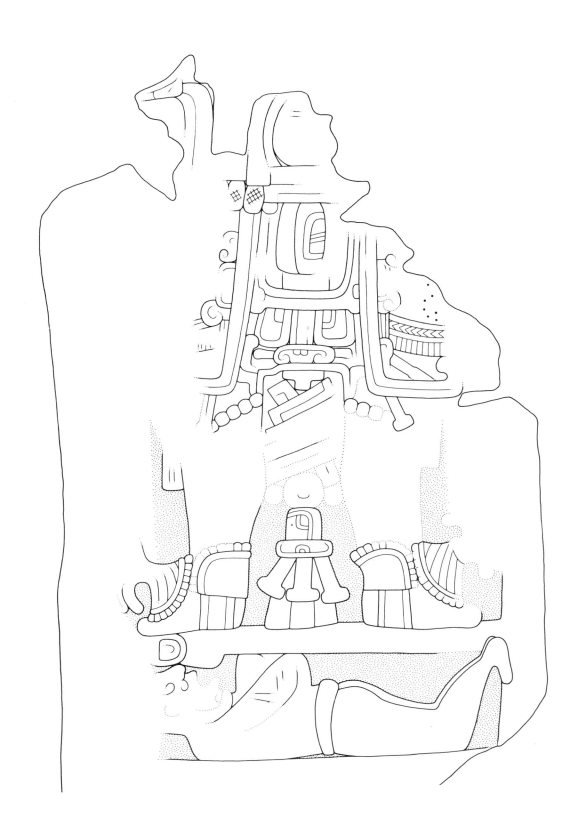

Front

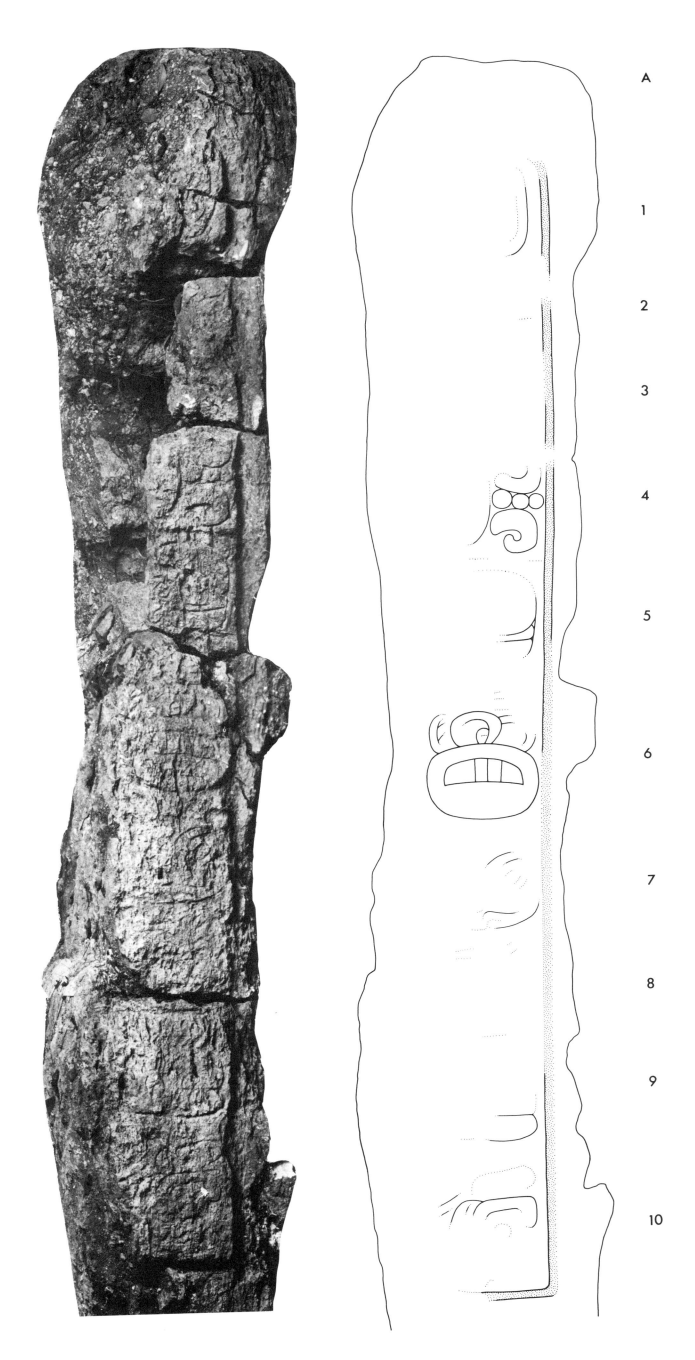

A

1

2

3

4

5

6

7

8

9

10

Left side

Right side

Xultun, Stela 15

LOCATION Between Stelae 14 and 16, facing Structure B-10.

CONDITION It was found lying face down by the CIW in 1920 and was turned on its right side for inspection. The stela remained in that position until 1975, when it was again placed face down. The butt of the stela is still in place. The right side has been destroyed almost totally by erosion, as has most of the front and large areas of the left side.

MATERIAL Poor quality limestone.

SHAPE Parallel sides, with slightly rounded top.

DIMENSIONS HLC 3.30 m
 PB unknown
 MW 1.40 m
 WBC 1.40 m
 WTh approximately
 0.78 m
 Rel 3.0 cm

CARVED AREAS Front and sides.

PHOTOGRAPHS von Euw.

DRAWINGS von Euw; based on field drawings corrected by artificial light.

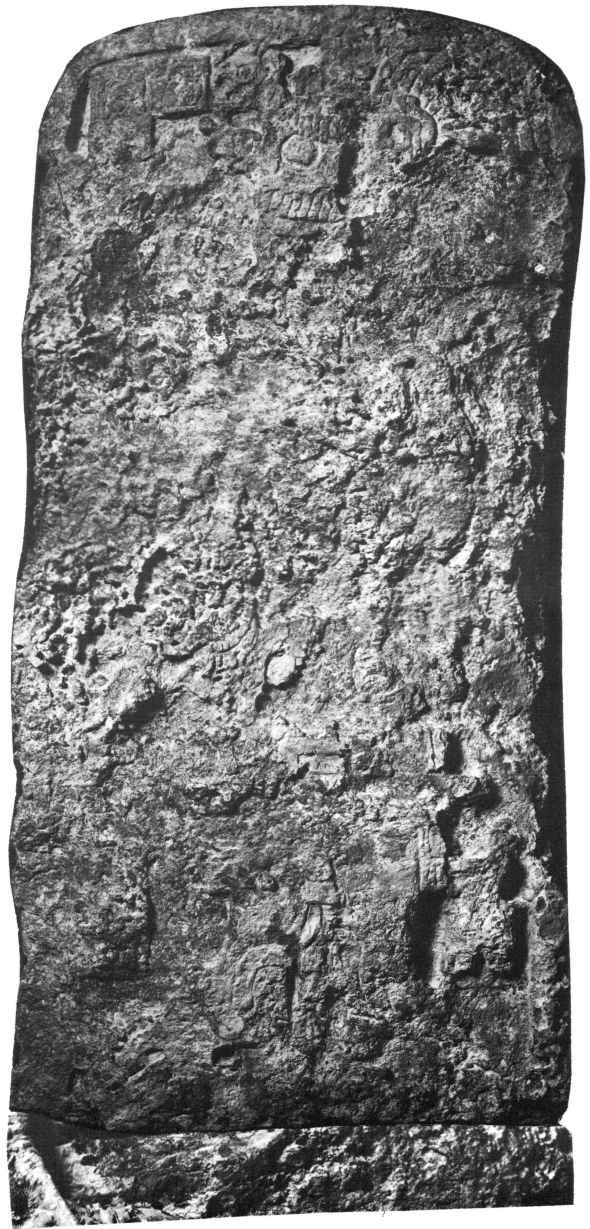

C D

1

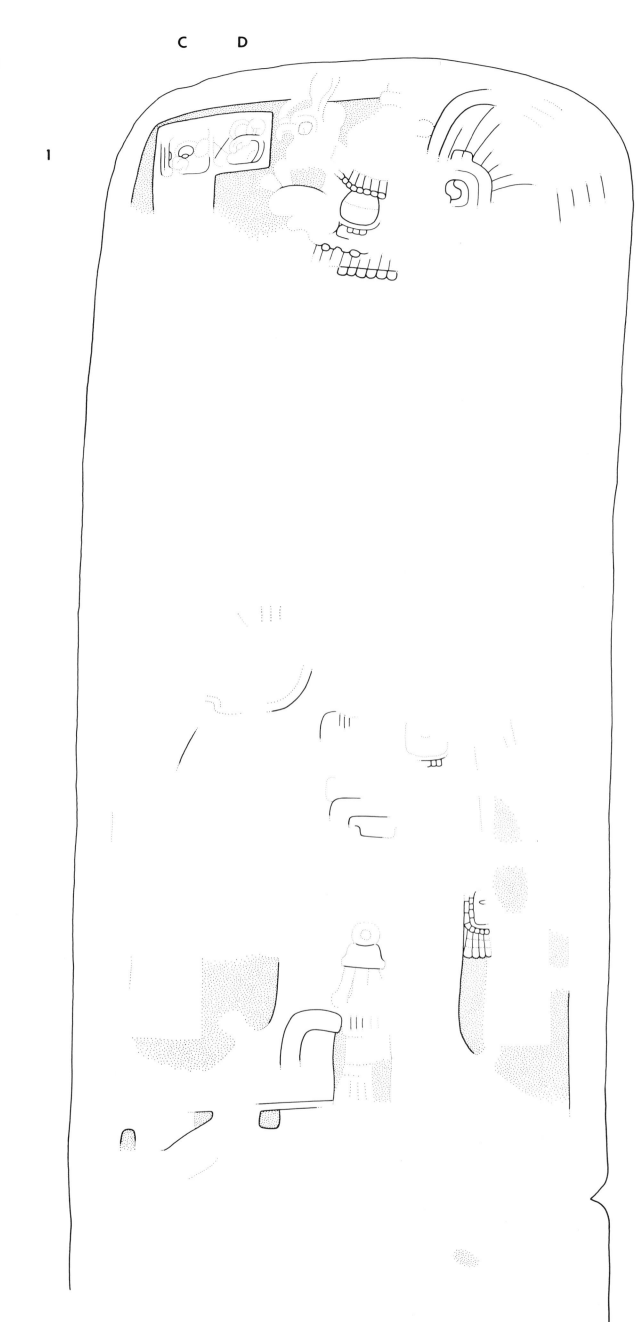

Front

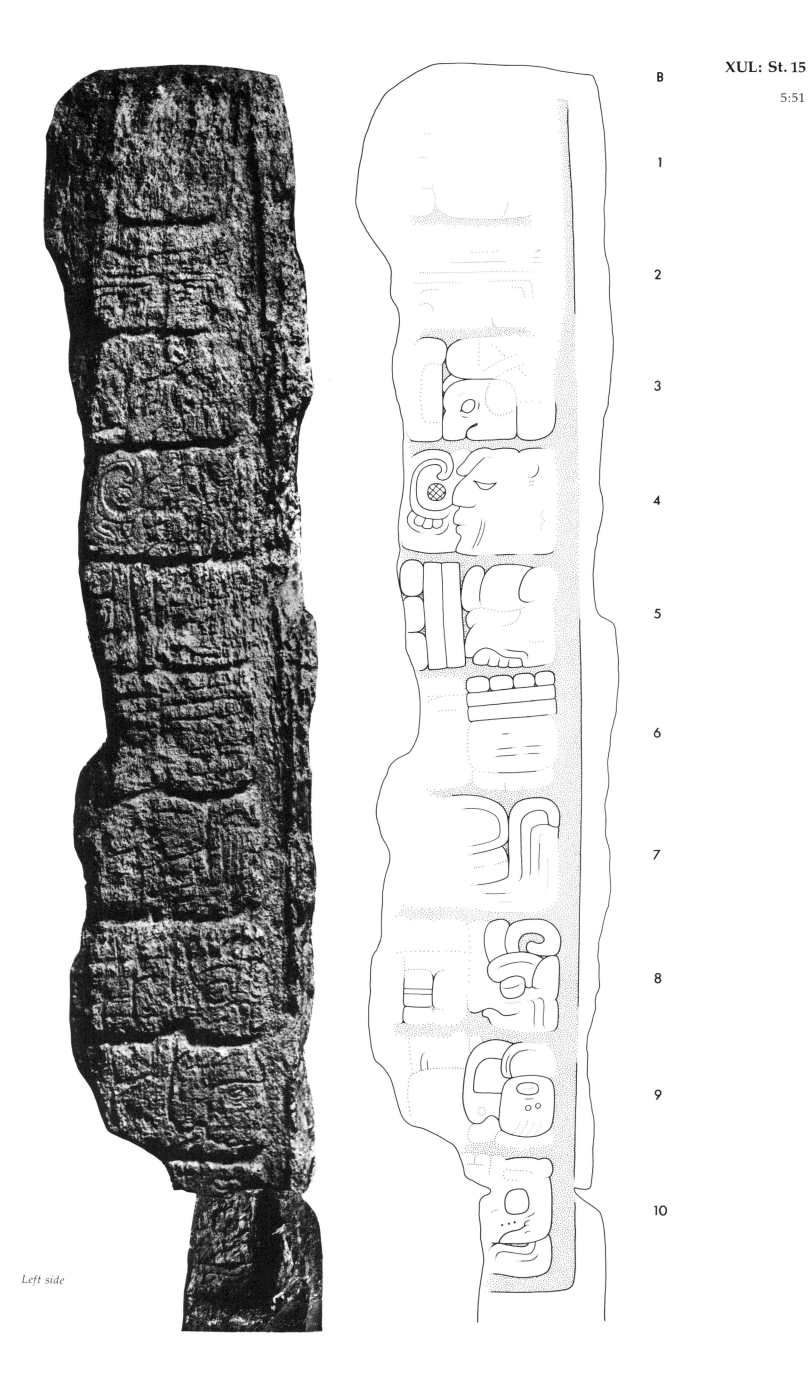

B

1

2

3

4

5

6

7

8

9

10

Left side

A

Right side

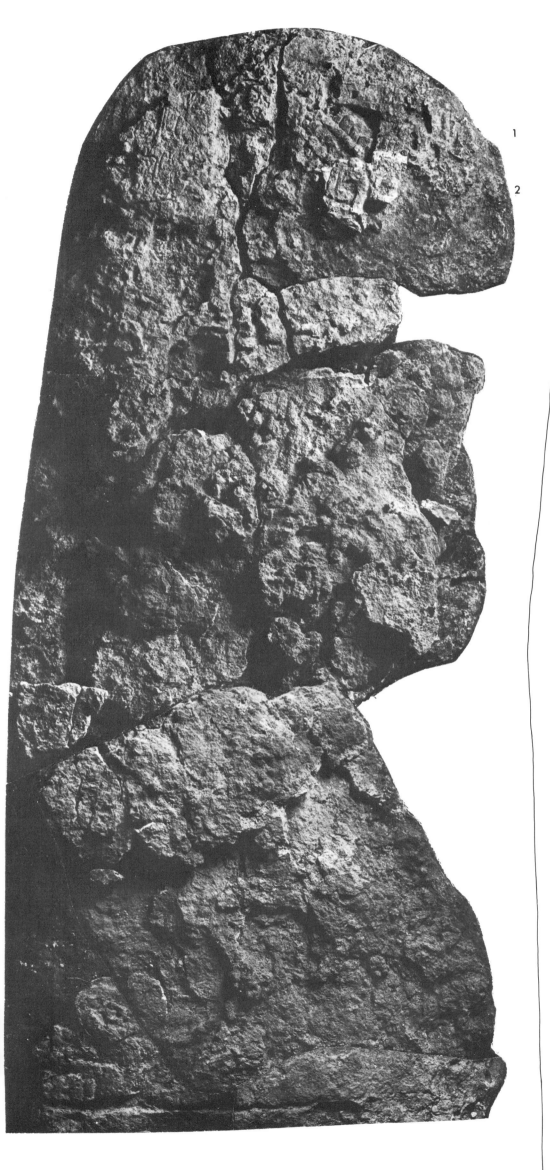

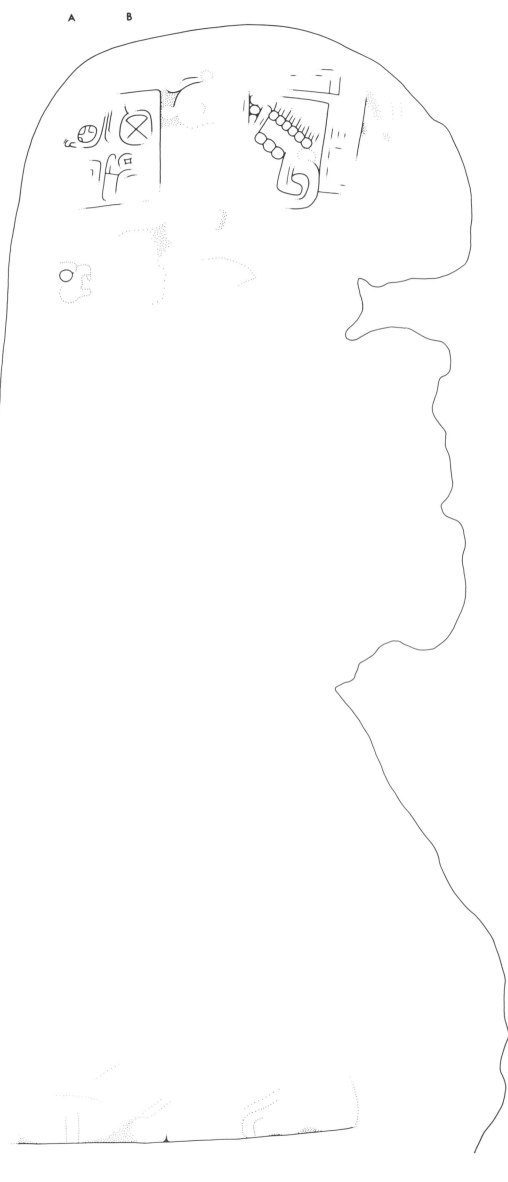

LOCATION Between Stelae 15 and 17 and facing the stairway leading up to Structure B-10.

CONDITION Stela 16 is broken into many pieces. Several fragments have crumbled and disappeared, and the portion surviving has lost almost all of its carving. Very few traces of sculpture remain on the left side of the stela, whereas, that on the right side has completely deteriorated. Stela 16 was left lying face up.

MATERIAL Porous limestone.

SHAPE Apparently parallel sides, with rounded top.

DIMENSIONS HLC approximately 2.94 m
PB 0.55 m plus
MW 1.30 m
MTh approximately 0.52 m
Rel approximately 3.5 cm

CARVED AREAS Front and sides.

PHOTOGRAPHS von Euw.

DRAWING von Euw; based on field drawing corrected by artificial light.

REMARKS There is an altar equidistant from this stela and Stela 17, rather than associated with this monument alone, as interpreted by Morley.

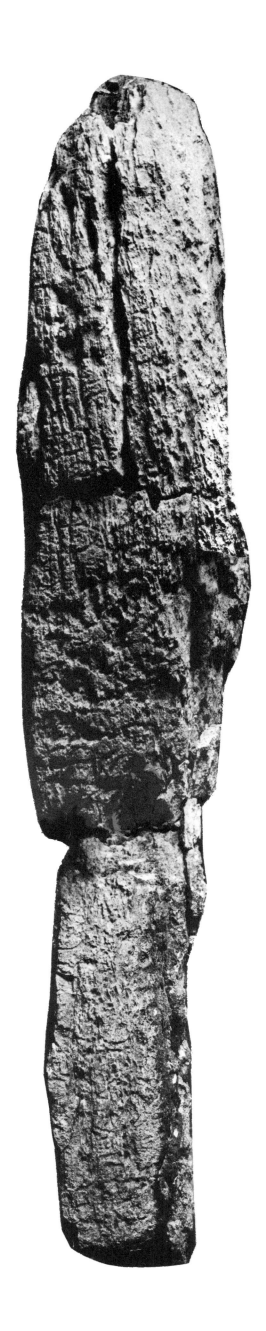

Left side

Xultun, Stela 17

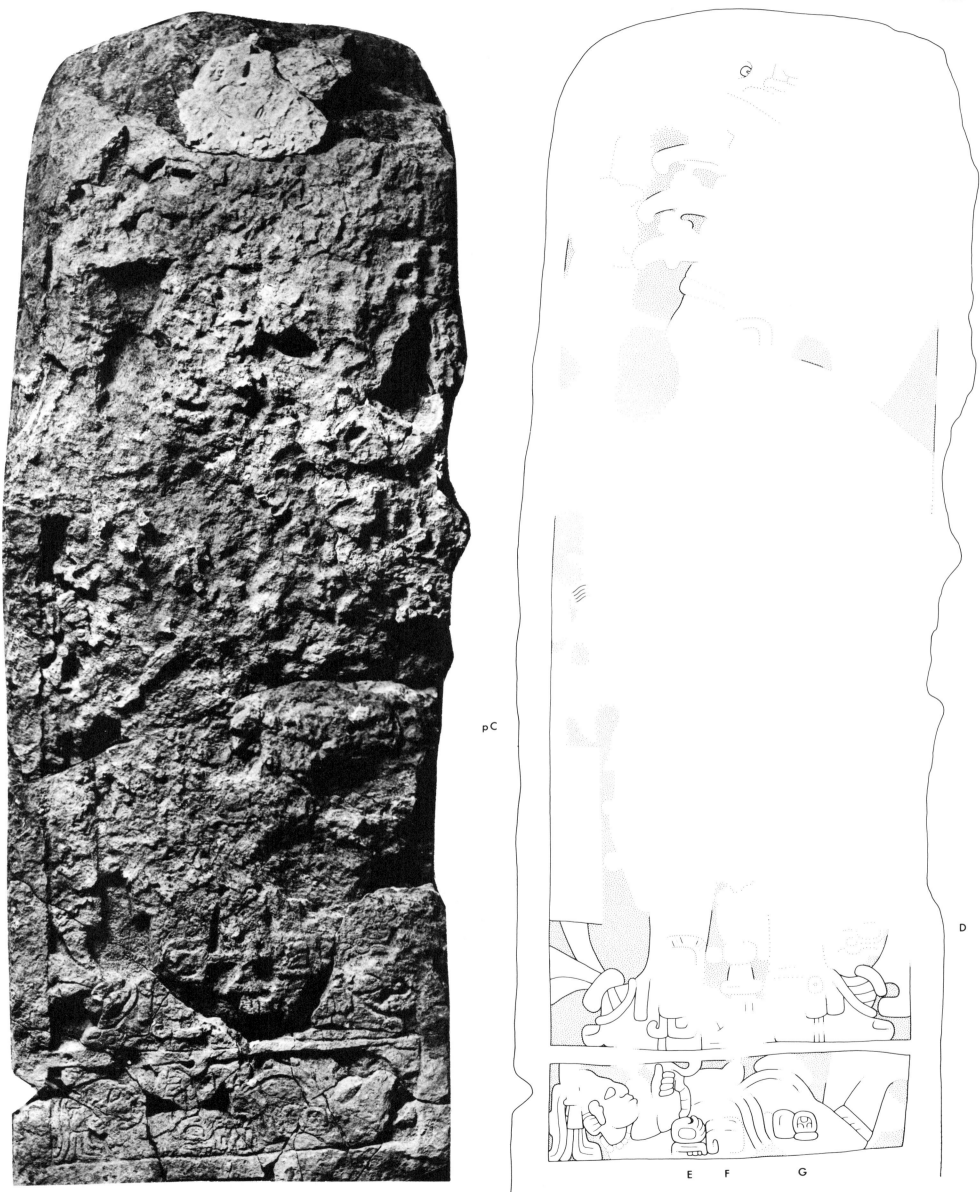

pC

D

E F G

LOCATION Northernmost of the five stelae in front of Structure B-10.

CONDITION When discovered by the CIW in 1920, the stela had a large *ramón* tree growing on it, which was crushing and effacing most of its carved surfaces. In 1975 the two large fragments were turned over and, as they did not include the base, a careful search was made for the lower portion of the monument. The thickness of the lower panel of the stela had been reduced by about 80 percent, and consequently it took substantial digging to expose the fragments. These were carefully reassembled, leaving only a few gaps in an otherwise complete and reasonably well preserved panel. The sides show little more than traces of carving.

MATERIAL Poor quality, porous limestone.

SHAPE Parallel sides, with slightly curved top.

DIMENSIONS HLC 3.10 m
 PB approximately
 0.50 m
 MW 1.16 m
 WBC 1.12 m
 MTh approximately
 0.74 m
 Rel 4.5 cm

CARVED AREAS Front and sides.

PHOTOGRAPHS von Euw.

DRAWINGS von Euw; based on field drawings corrected by artificial light.

REMARKS There are traces of red paint in the background area above the face of the personage. The bottom panel was buried near the base of the stela. Morley did not indicate an altar for this monument, but it is unclear whether the nearest altar was associated with this stela or with Stela 16, or both.

B

Left side

A

Right side

Xultun, Stela 18

LOCATION Southernmost of the four stelae (Stelae 18 to 21) facing Structure B-7.

CONDITION The top fragment was discovered lying on its face in 1921 by the CIW. It was left lying on its side and has suffered little deterioration since then, although it has been rather badly stained by lichen. Morley apparently never saw the butt of this stela, which was nearby enveloped by a large *ramón* tree. The laborious removal of the tree in 1974 unfortunately yielded no new sculptured details, the roots of the tree apparently having obliterated the carved surfaces. The fragment is approximately 1.30 m long. The top of the stela was never found and has probably disintegrated.

MATERIAL Poor quality limestone.

SHAPE Parallel sides. Form of top unknown.

DIMENSIONS (fragment illustrated)
H 2.10 m
MW 1.35 m
MTh approximately 0.40 m
Rel 2.7 cm

CARVED AREAS Front and sides.

PHOTOGRAPHS von Euw.

DRAWINGS von Euw; based on field drawings corrected by artificial light.

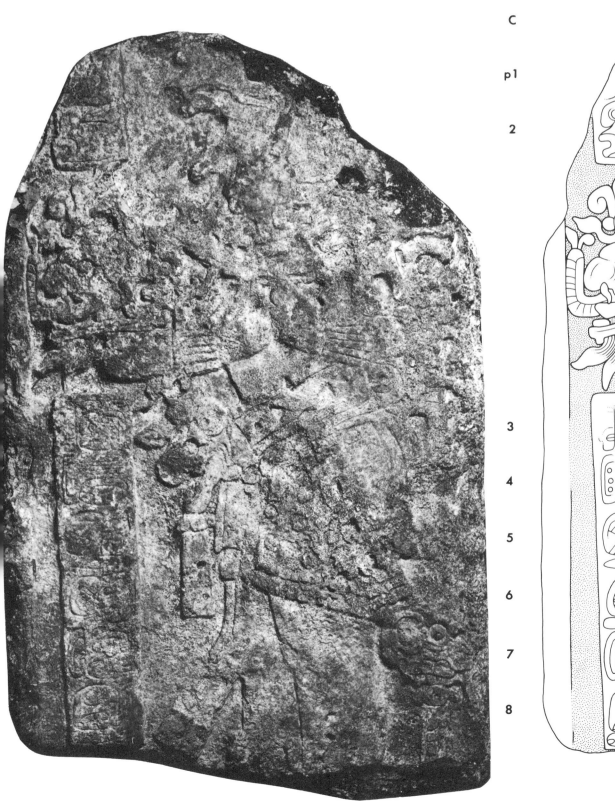

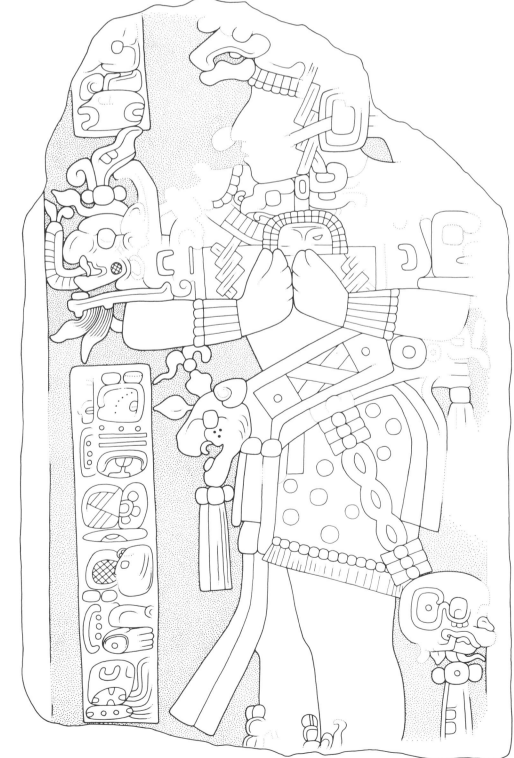

XUL:St.18

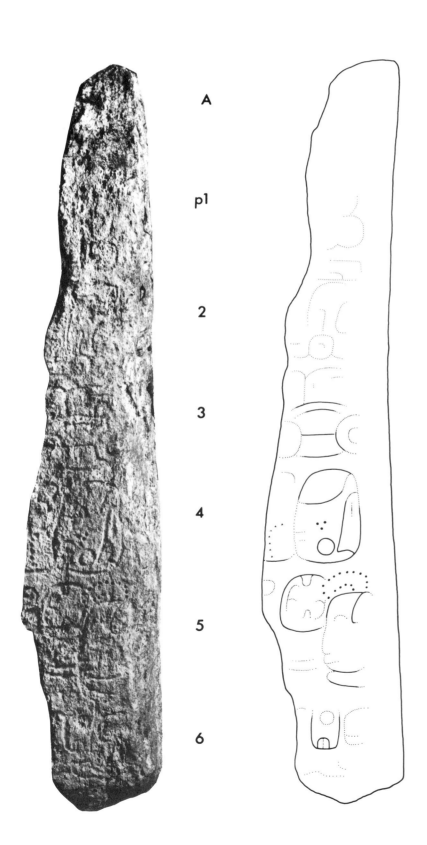

A

p1

2

3

4

5

6

Left side

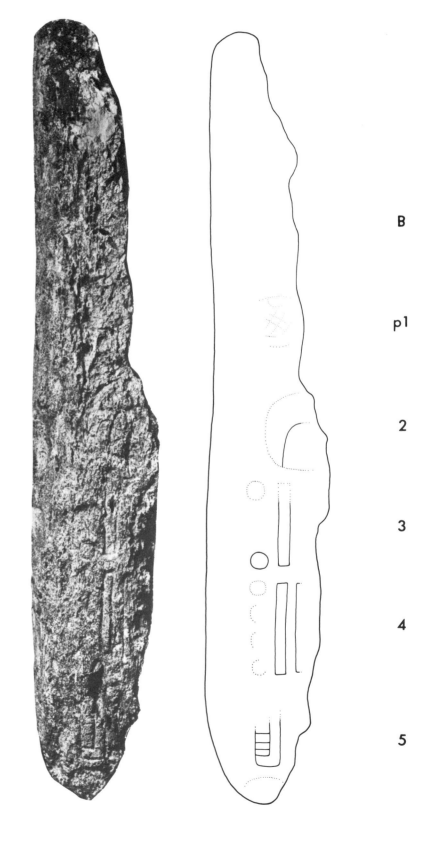

B

p1

2

3

4

5

Right side

Xultun, Stela 19

LOCATION Between Stelae 18 and 20 on the west side of (and facing) Structure B-7.

CONDITION Most of the stela has disappeared. The top piece is the only fragment on which the sculpture has survived and here, too, a considerable portion has flaked off or weathered away. It was found lying face down in 1921 by the CIW and was left lying on its side. A groove along the border in the sides is the only indication of previous carving. The other fragment found is so completely eroded that the front cannot be distinguished from the back.

MATERIAL Poor quality limestone.

SHAPE Sides gradually tapering to a flattish top.

DIMENSIONS Top fragment
H 1.84 m
MW 1.24 m
MTh approximately 0.53 m
Rel 1.7 cm

CARVED AREAS Front and sides.

PHOTOGRAPHS von Euw.

DRAWING von Euw; based on field drawing corrected by artificial light.

REMARKS No altar was found associated with this monument, although one appears in Morley's map.

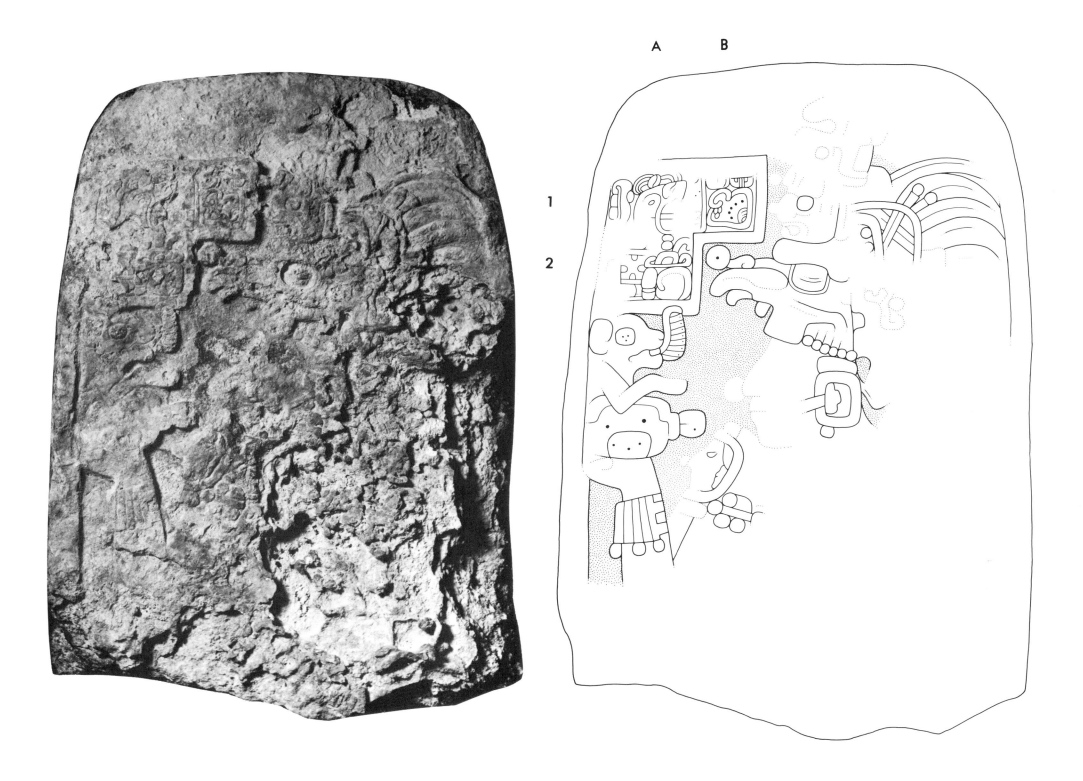

Left side *Right side*